Velázquez

Masters of Art

Velázquez

Rosa Giorgi

PRESTEL
Munich · London · New York

Front cover: *Las Meninas* (detail), ca. 1656, Museo Nacional del Prado, Madrid, see page 125
Frontispiece: *The Coronation of the Virgin* (detail), ca. 1635
Museo Nacional del Prado, Madrid, see page 103
Back cover: *The Surrender of Breda* (detail), 1635, Museo Nacional del Prado, Madrid, see page 79

© Prestel Verlag, Munich · London · New York, 2012
© 2007 Mondadori Electa S.p.A., Milan

British Library Cataloguing-in-Publication Data: a catalogue record for this book is available from
the British Library; Deutsche Nationalbibliothek holds a record of this publication in the Deutsche
Nationalbibliografie; detailed bibliographical data can be found under:
http://dnb.d-nb.de.

The Library of Congress Number: 2012939408

Prestel Verlag, Munich
A member of Verlagsgruppe Random House GmbH

Prestel Verlag
Neumarkter Strasse 28
81673 Munich
Tel. +49(0)89 4136 0
Fax +49(0)89 4136 2335

www.prestel.de

Prestel Publishing Ltd.
4 Bloomsbury Place
London WC1A 2QA
Tel. +44 (0)20 7323-5004
Fax +44 (0)20 7636-8004

Prestel Publishing
900 Broadway, Suite 603
New York, NY 10003
Tel. +1 (212) 995-2720
Fax +1 (212) 995-2733

www.prestel.com

Prestel books are available worldwide. Please contact your nearest bookseller or one of the above
addresses for information concerning your local distributor.

Editorial direction: Claudia Stäuble, assisted by Franziska Stegmann
Translation from Italian: Bridget Mason
Copyediting: Jonathan Fox
Production: Nele Krüger
Typesetting: Stephan Riedlberger, Munich
Cover: Sofarobotnik, Augsburg & Munich
Printing and binding: Mondadori Printing, Verona, Italy

Verlagsgruppe Random House FSC-DEU-0100
The FSC-certified paper *Respecta Satin* is produced
by Burgo Group Spa., Italy.

ISBN 978-3-7913-4742-4

Contents

Introduction

The court register for August 6, 1660 carries the notice of the death of Diego Velázquez, painter to King Philip IV and Knight of the Order of Santiago. The entry is accompanied by a brief note in the king's hand: "I am desperate." This was not just the death of an artist, it signaled the end of an era.

The splendid Golden Age of cultural glory that masked the symptoms of an irreversible political, financial, and military crisis makes Spain an incontrovertible point of reference for attempting to get to grips with the unrest and splendor that marked a controversial and fascinating era. Velázquez was the shining star of the times, an intriguing and complex man. His paintings, like the great literary output of the time, reflect an entire century; yet while Velázquez's paintings provide the most faithful portrait of life at the court of Madrid, some of the emotions, situations, and people emerge from the contingencies of their time to become archetypes in their own right. For example, of all the portraits of court jesters, the most disturbing portraits are undoubtedly those of the dwarves. In a decidedly modern take, Velázquez gives no quarter to ridicule or to ironic emphasis of their deformities. Quite the reverse, he exalts the enormous dignity, the sharp sensitivity, the superior and painful intelligence of these unfortunate people. Their faces, atop their puppet-like bodies, are full of powerful communicative force and moral energy, making the wan, nerveless Baroque portraits of the courtiers seem paler still. Velázquez grew up in Seville before moving to Madrid where he became the court painter for several decades. But his dealings with Philip IV were not merely confined to the dry business of supplying works of art; almost a century later, they enjoyed the same sort of relationship as Charles V and Titian at the court of Spain. Titian was a stylistic role model for Velázquez, who brought his rich, fleshy colors back to life, especially in his vibrant portraits of the king, his family, and the people who moved around the court. Velázquez, however, was

equally influenced by Caravaggio, to whom he had devoted careful study during his two lengthy sojourns in Italy. Seventeenth-century European painting as a whole was affected by Caravaggio's use of diagonal light and shadow, but Velázquez did not merely master his technique of chiaroscuro, he also harnessed the very essence of Caravaggio. It may be fair to say that no other artist has managed to comprehend so well the lyrical poetry, the daily grind, and the short-lived happiness of a dusty, poor world, rent asunder and yet alive, bursting with humanity and truth. He was a marvelous interpreter of the most resplendent court dress, and his imperious equestrian statues were masterful, but he also knew how to paint blacksmiths, beggars, and paupers in rags, portraying the opposite extremes of his age in parallel, yet entirely without rhetoric. His life and career effectively culminated in one of the most extraordinary and fascinating paintings in the entire history of art: *Las Meninas*. It belongs in the tradition of court portraits, showing the infant being fussed over by her ladies-in-waiting. The apparently simple composition is complicated with the reflections of the faces of the king and queen in a mirror at the back of the room. The longer one looks, the more conscious one becomes of its complexity, the presence of other figures, lights, and details. It is a sophisticated masterpiece, the spaces surprisingly overturned, a magic chessboard. The king and queen are both onlookers and protagonists; their images in the mirror suggest (as in Van Eyck's *Arnolfini Portrait* many years earlier) that they must be "on the other side" of the painting, next to us. A further denouement is the self-portrait of the artist himself painting this very picture, on the left. This is the final leap in our interior/exterior, front/back, past/present mental gymnastics. There is no more to be said: Velázquez has us well and truly hooked.

Stefano Zuffi

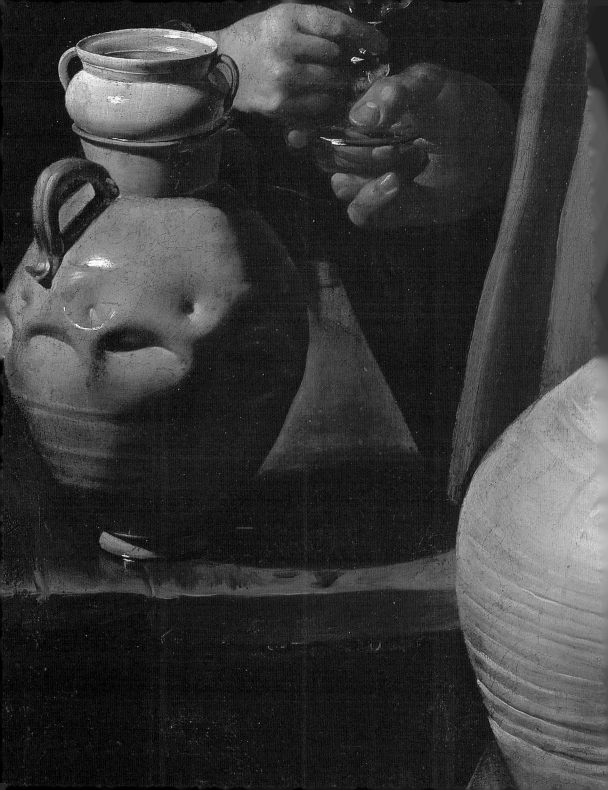

LIFE

The Glorious Golden Age

Diego Rodríguez de Silva y Velázquez was born in Seville in late spring 1599, and was baptized in the church of San Pedro on June 6. His father, Joao Rodríguez Silva, was of Portuguese extraction, from the city of Oporto, while his mother, Jerónima Velázquez, was from Seville. Diego took his mother's surname, along with that of his father (as evidenced on documents of the time), which was the Portuguese custom and frequently also the case in Andalusia as well. As so often with families who moved from Portugal to Seville during the late sixteenth century, his father may have had distant Jewish roots, while his grandparents' noble ancestry, which Velázquez traded on much later, was by no means certain. Antonio Palomino (painter at the court of Philip V), who compiled his biography during the eighteenth century in a weighty tome inspired by Vasari's similar literary endeavors, not only placed great emphasis on it, but also insisted that Velázquez's father's family, the de Silvas, were descended from no less a figure than the mythical Aeneas Silvius, King of Alba Longa. In any event, these pretensions towards nobility had no particular financial or social repercussions on the life of the future artist. What did prove extremely seminal was the

lively and stimulating environment into which he was born and in which he grew up: the flourishing city of Seville.

The Formative Years

Seville was not just the most crowded city in Spain during the period spanning the sixteenth and seventeenth centuries when the Golden Age was in full swing, it was also its richest in all senses. Its strength was determined by the fact that it was on the cusp of becoming a cosmopolitan city, a tremendous asset that rendered it particularly accessible and diverse. Diego Velázquez was not only born into a noble, cultured family—thanks to the humanist flavor of Seville during the first half of the century—he also grew up in a vital, multifaceted city. Seville's good fortune derived from its trade monopoly with the New World due to the Catholic monarchs, which meant that it attracted a large number of foreign, largely Flemish and Italian (most of them Genoese) merchants that had brought great vitality to the city.

However, alongside the human and cultural benefits of the new trade agreements, there was also an underground world, made up of adventurers and people marginalized by

Opposite page:
The Immaculate
Conception
1618–19
The National Gallery,
London

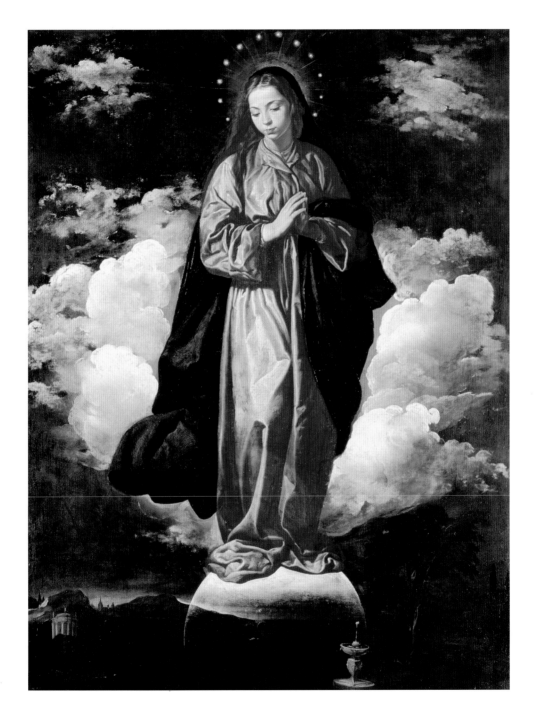

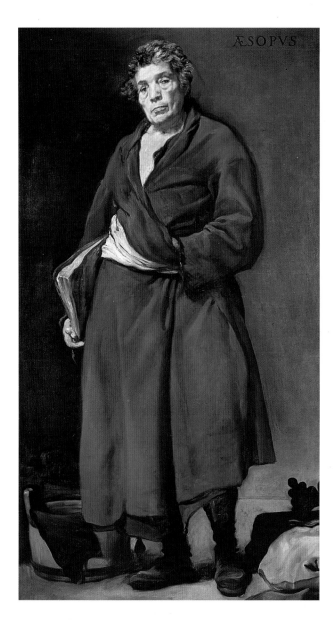

ÆSOPVS

Aesop
ca. 1638
Museo Nacional del
Prado, Madrid

organized society. This was the underbelly of prosperous Seville, the lowlife that frequented the brothels, filled the hospitals, and demanded the constant intervention of the numerous religious bodies engaged in charity work on behalf of the monasteries, distributing bread or assistance, treating and taking in vast numbers of disadvantaged people. It was certainly an extremely lively place, but this was offset by some very real drawbacks: the city still had the incredibly narrow streets built during its medieval Islamic period, which were extremely tricky to navigate by coach and highly risky at night; a virtual anarchy reigned in the way the urban center was organized, with illegal humble dwellings erected right next door to gentlemen's residences in the vicinity of the Cathedral. There were no road signs and the streets were often referred to in popular parlance, added to which the city of Seville was far from clean, so that at least eight streets were dubbed "Dirty" over the course of the sixteenth century. Some parts of the city were extraordinarily animated, such as the buzzing commercial district around the Cathedral steps, behind the House of Trade, and around the quarter of the *Francos*. Crime eventually reached alarming proportions. Underworld gangs known as confraternities, bent on organized crime, abounded—all recorded for posterity in the memorable descriptions in Cervantes's novel *Rinconete y Cortadillo*. All these different environments contributed to the formation of the future artist, destined to become the subjects of genre paintings known as *bodegónes*, still lifes that also included figures, often set in unusual locations, usually decidedly humble ones

(lodging houses, or dark kitchens), and "frequented" by the sort of people who might well have leapt straight out of the pages of some picaresque novel. Velázquez's early work was peopled by the street vendors, servants, and passers-by he would have come across in the streets of Seville rather than by dastardly underworld characters.

He first studied painting at the age of ten under Francisco Herrera the Elder. Francisco Herrera, along with Francisco Pacheco and Juan de Roelas, who were older than he, was one of the leading exponents of early naturalism in Seville. His talent and powerful personality meant that he soon carved out a place for himself in the local art world, and must have been between twenty and thirty years old at the time Velázquez joined his workshop. However, possibly because of his exceptional drive, he was described by Palomino as "a rigid master but of consummate ability." He was a hard man, which may explain why the young Velázquez only spent a short time in his workshop before moving on. He then became apprenticed to Francisco Pacheco, joining his workshop on December 1, 1610, although the contract between the latter and his father was not formalized until September of the following year. This sort of contract would normally have lasted for between four and six years, during which time the masters were required to provide board, lodging, and clothing for their apprentices, but were not permitted to ask them to perform any menial work. In return, the apprentices were allowed to help their masters with small, secondary tasks such as the preparation of colors or canvases. It would appear that during 1611, which may

have been a trial period, the artist and his pupil got on well and respected each other, since a six-year contract was eventually signed, the maximum allowed. Pacheco was actually a fairly mediocre painter, but was one of the best known and greatly respected in Seville, and his teaching proved decisive for the particular way of conceiving painting as a high art form. He had important friendships with members of the Sevillan nobility and in religious circles (especially among the Jesuits), and his home tended to be frequented by the intelligentsia and therefore proved to be an extremely stimulating environment for a young artist. In early spring of 1617 (March 14), Velázquez took and passed the obligatory exam for all artists to practice autonomously, a requirement set by the Catholic monarchs during the previous century (1543). The examiners that particular year were Pacheco and Juan de Uceda, a Sevillan painter of the same generation, and when putting Velázquez forward for his license, after he had passed all the practical and theoretical tests, they both asked specifically for him to be granted the right to work throughout the kingdom, though licenses were typically local. Newly qualified painters had to swear allegiance "to God and the Cross" as a commitment to "employ this art well and faithfully" and to respect all the relative ordinances. Velázquez, too, made his solemn oath and officially embarked on his future career as a master painter. He was now in a position to set up his own workshop and enter into contracts with apprentices of his own, and to collaborate with other artists.

A new chapter in his life opened with his entry into the ranks of master painters, which

began with his marriage. According to guild tradition, at the age of nineteen he married Juana Pacheco, the daughter of his master and three years younger than him, at the church of San Miguel. Pacheco considered his young pupil to be a man of virtue and talent, and was keen to establish permanent ties with him and his own workshop. The avenues open to Velázquez were the same as those open to all the other painters of his generation: their clients, who were largely ecclesiastical, wanted religious themes and devotional paintings, portraits, monastic cycles, and still lifes. However, a burgeoning interest in naturalism—also embraced by the Church as a means of bringing people to religion and combating the intellectual abstraction suggested and occasionally imposed by the Protestant Reformation with direct images—opened another creative avenue. It was during this period that Velázquez perfected his skill in painting from nature, through his own treatment of volumes and the use of different materials, as well as employing the novel device of chiaroscuro, also known as tenebrism, for which the study of inanimate objects proved to be an excellent testing ground. He continued to produce genre paintings, inserting still lifes wherever he deemed it natural, as in the *An Old Woman Cooking Eggs* (1618, National Gallery of Scotland, Edinburgh), *Three Musicians* (1616–17, Staatliche Museen, Berlin), *Tavern Scene* (ca. 1617, Hermitage, Saint Petersburg), *Kitchen Maid with the Supper at Emmaus (La Mulata)* (ca. 1617–18, National Gallery of Ireland, Dublin), and *The Waterseller of Seville* (ca. 1620, Wellington Museum, Apsley House, London).

Having accomplished this, he then contrived to introduce ordinary, everyday elements into compositions calling for religious iconography, with naturalism and familiarity: in *Christ in the House of Martha and Mary* (1618, National Gallery, London), *Saint John the Evangelist on the Island of Patmos* (ca. 1618, National Gallery, London), or the *Adoration of the Magi* (1619, Prado, Madrid), using members of his own family as his models.

Madrid: The Arrival at Court

Velázquez made his first real acquaintance with the royal court in 1622. The Spanish king, Philip III of Hapsburg, had died on March 31 the previous year, and his successor, the sixteen-year-old Philip IV, had appointed Don Gaspar de Guzmán y Fonseca, Count and future Count-Duke of Olivares, a Sevillan nobleman born and educated in Rome, as his prime minister. This appointment was music to the ears of the Sevillan artists, because the young king's counselor, an intelligent and ambitious man, immediately thrust his cronies and compatriots into strategic positions of power. Like others keen to embark on a glittering career, Velázquez followed Pacheco's advice and set off for Madrid full of expectation. He made his first journey to Madrid and the royal palace with his pupil, Diego de Melgar, who had spent a couple of years in his workshop, Velázquez nursing a lofty ambition to paint the king's portrait. But this was not to prove the right time, and the only work he managed to complete was a portrait of Philip IV's court poet and honorary chaplain, Luis de Góngora y Argote (1622, Museum of Fine Arts, Boston), at the express request of Francisco Pacheco,

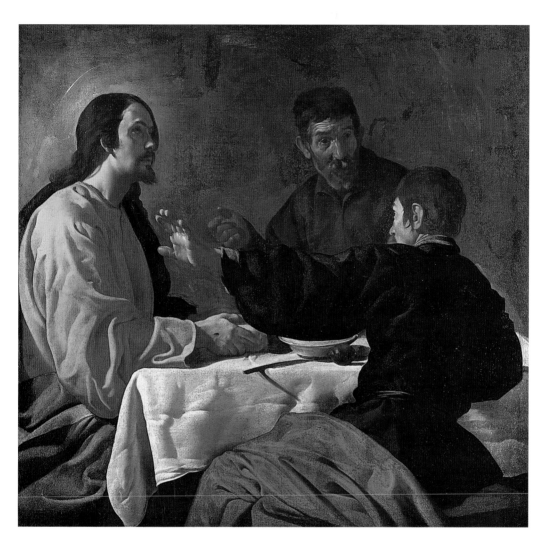

The Supper at Emmaus
1622–23
The Metropolitan
Museum of Art,
New York

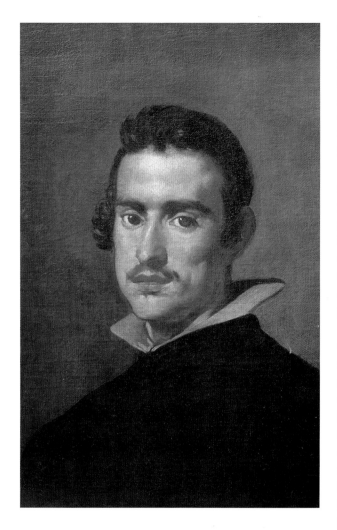

Portrait of a Man
(Self-Portrait?)
ca. 1623
Museo Nacional del
Prado, Madrid

who was keen to encourage contacts with Andalusians living in Madrid. He is likely to have taken the opportunity to visit the royal collections at El Pardo, the Escorial, and Aranjuez Palace, and to get himself noticed at court during his brief sojourn (he returned home fairly quickly). It was not long before his efforts bore fruit. A year later, in August 1623, Velázquez was summoned to Madrid by Count Olivares, not least because the court painter Rodrigo de Villandrando had died the previous December. This was to be his big break: he returned to Madrid with his pupil and servant Juan de Pareja, initially staying at the residence of Juan de Fonseca, *sumiller de cortina*, not far from the Alcázar. He made a portrait, presumably for his host (*A Man*, 1623/30, Detroit Institute of Arts), which provided his entree to court. The portrait, which rather than idealize the sitter contained an abundance of details taken from life, and was so expressive and communicative of his subject's stature, was thought of so highly by the entire court and the king, that the latter commissioned his own portrait immediately. Velázquez's first portrait of the king is thought to be the Dallas portrait (ca. 1623–24, Meadows Museum at Southern Methodist University). It is not a full-length portrait, representing just the head and shoulders, but the artist's skilled treatment of light and his use of what appeared to be a limited palette, enabled the painting to convey a regal expression, both superior and detached. The portrait was, of course, a huge success, and, once the summer was over, in early October, Velázquez was appointed painter to the king, at a salary of twenty ducats a month, residential quarters

at the palace, with the services of the palace doctor and pharmacy at his disposal; in return he was expected to execute any paintings requested of him, and, after a short while, extra pay became forthcoming for works commissioned by the king himself. Given the nature of his position and duties at court, Velázquez moved his family to Madrid. They lived at the royal palace, where he had his studio, and he worked in the king's service from then on, living the life of a court dignitary. The fact that there was a painter actually living at the king's palace is evidence of just how great a symbol of political power artistic wealth could be; in fact, what better evidence of governmental prowess than paintings commissioned by the monarchy? The many early portraits of members of the royal family, executed after that of the king, include the portrait of Gaspar de Guzmán, Count-Duke of Olivares (1624, Museu de Arte, São Paulo) commissioned alongside that of the attorney general, García Pérez de Araciel (posthumous, since he died in 1623), another portrait of the king, full-length this time, followed later by a portrait of the king's brother, the Infante Carlos (1626–27, Prado, Madrid), which could be used as diplomatic tools, alongside celebratory paintings on great historical themes. Even the views of Spanish and foreign cities could be said to contain a veiled political intent to remind the ruler of his own dominions and inform the visitor as to the territorial assets of the nation he was dealing with. Velázquez tackled all these subjects extremely skillfully, excelling in portraiture and attracting the envy of his fellow painters (especially the other six court painters, who were

all extremely able, but older and inexorably rooted in their sixteenth-century Italian traditions), who nastily claimed that "all his mastery comes from knowing how to paint a head." It is an odd criticism, given that Velázquez was honing his skills as a portraitist just as he joined the court and, being obliged to give up painting heads and shoulders in favor of full-length portraits—for obvious reasons of etiquette—was executing more complex compositions based on the works of previous royal painters, and was by then devoting himself to considerably more than just "painting heads." In actual fact, this criticism simply served to underscore how low portraiture was rated, in comparison to the many other genres. He seemed to find courtly life congenial and was able to give full rein to his skills, despite the envy of his rival painters. Court life proved crucial to the building of a network of acquaintances that gained him both immediate and future important and prestigious commissions. In particular, as well as the various diplomatic visits that brought him into contact with the nobility and high-ranking officials from leading European courts, he met Peter Paul Rubens in 1628, who was on a diplomatic mission for the ruler of Flanders geared to brokering the end of the Thirty Years' War. It was a meeting that was to prove seminal. Rubens spent almost a year in Madrid, carrying out his mission. It was a special time, during which he gained the admiration of Philip IV, who put him up at the royal palace, where he had occasion to familiarize himself with the king's collection, studying and copying works by Titian in particular. He is likely to have worked in Velázquez's

studio; they were both great admirers of Titian, valued for his creative force as well as for the personal prestige he had acquired. His meeting with this extraordinary painter may have sparked Velázquez's request to be sent to Italy, on a study tour.

First Visit to Italy

After six years at court and two months after Rubens's departure, Velázquez was granted permission to travel to Italy on a study tour. He left Madrid on July 30, 1629, and ten days later set sail for Italy from Barcelona, on the Feast of St. Lawrence. The king gave him four hundred silver ducats, the equivalent of two years' salary, and the count-duke gave him another two hundred gold ducats, a medal bearing the likeness of the king, and several letters of introduction. Although the reason for his trip was to bring himself up to date on Italian art, he officially presented himself as a gentleman usher (a post he had earned previously after a competition of sorts organized by Philip IV between the court painters), which triggered not a few suspicions, since artists were frequently roped into carrying out "secret missions." He set out with the Marquis Ambrogio Spinola, governor of Lombardy and commander of the Spanish troops in Italy, and arrived in Genoa on September 19. Velázquez then left for Milan, after which he traveled via Parma to Venice, where he stayed with the Spanish ambassador, Count Cristóbal de Benavente Benavides. He made the most of his time in Venice (accompanied by the ambassador's servant, as always, given the political situation—Venice was then at war with Spain), studying the work of Tintoretto and Veronese

in the Basilica and Accademia di San Marco. He spent as much time as he could in the Grand Council Chamber in the Accademia di San Luca, studying and sketching the great works of the Venetian masters (from Titian to Veronese, Licino, Bassano, Bellini, Palma, Giorgione, and Sansovino), before leaving Venice. On his way to Rome, he stopped in Ferrara, where he stayed with Cardinal Giulio Sacchetti, a former Apostolic Nuncio in Madrid, and then went on to Cento and Loreto, skipping Bologna and Florence.

He arrived in Rome in 1630, where he spent a year, becoming a favorite of Cardinal Francesco Barberini, nephew of Pope Urban VIII. He immediately took up residence in the Vatican Palaces, in rooms frescoed by Taddeo Zuccari. Thanks to the cardinal, he was also allowed a key to other rooms and was able to move around the Apostolic Palace with some degree of freedom, with unrestricted access to the Sistine Chapel and the rooms frescoed by Raphael. Despite the luxury of his surroundings and privileged hospitality, Velázquez decided to move on, partly because he spent so much time on his own, but mostly because he wanted an opportunity to study classical sculpture. He moved to the Palazzo Medici at Trinità dei Monti, thanks to the Ambassador Count of Monterey's intervention with the Tuscan ambassador. Here he spent two of the summer months (before falling ill and having to be treated by the Spanish ambassador's doctor) in an altogether airier part of Rome where he was close to the palace antiquities, which he studied and copied carefully, later using them as source material and iconographic models. While in Italy, he

mainly made the sorts of drawings he had executed previously in Seville, using blue paper, charcoal, and gesso in a constant attempt to find the aptitude for reproducing the different expressions and trying to master the techniques of the masters who had preceded him.

The few surviving drawings are sober, synthetic attempts at faithful reproduction, showing that even in his preparatory studies Velázquez was able to capture the essence of his models, with clarity of light and essential plays of chiaroscuro.

He felt at ease in Rome especially, where he developed and blended the rigor and equilibrium encountered in Bologna with the sensitivity of Venetian colorism in his major canvases of the period: *The Forge of Vulcan* (ca. 1630, Prado, Madrid) and *Joseph's Bloody Coat Brought to Jacob* (1630, Monasterio de San Lorenzo, El Escorial). Before returning to Spain, he made a final stop in Naples, where, at the request of Philip IV, he painted a portrait of the king's sister, the Infanta Doña Maria, prior to her arranged marriage to the king of Hungary (*Maria de Austria, Queen of Hungary*, ca. 1630, Prado, Madrid). After executing the king's commission, Velázquez finally took his leave of Italy.

The Return to Madrid

By the time he went back to Spain after a year and a half in Italy, Velázquez's artistic training was complete. He was warmly welcomed back by the count-duke and the king, who had not sat for a single portrait in the meantime, nor indeed allowed any portraits to be made of his little heir, Prince Baltasar Carlos, born after

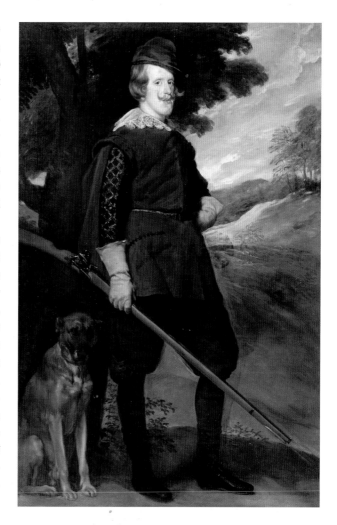

Felipe IV in Hunting Garb
ca. 1635
Museo Nacional del Prado, Madrid

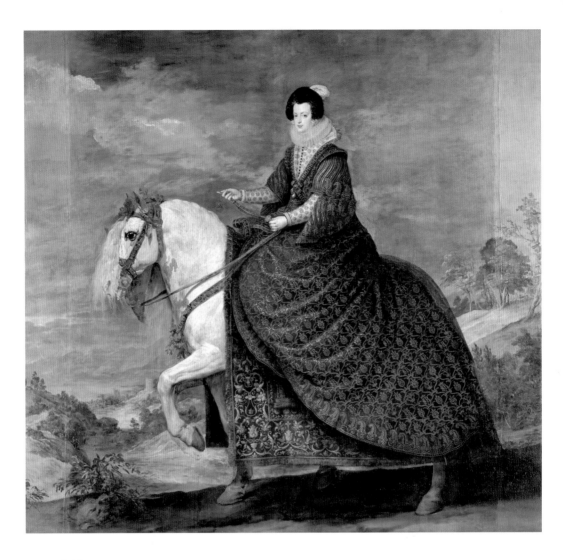

*Queen Isabel de
Bourbon, Wife of Felipe
IV, on Horseback
1635–36
Museo Nacional del
Prado, Madrid*

Velázquez had left for Italy, and picked up his life at the palace again. He resumed all his duties as court painter, and took up the religious subjects that had interested him at the beginning of his career in Seville, honing his new skills and alternating holy and devotional works with court paintings, all at the king's behest, however. There was now a faintly classical tenor to his work, deriving from the Italian artists, both in terms of approach (as in *Christ Crucified* in the Prado, Madrid, made in ca. 1632), and in terms of his use of colors, with which he contrived extraordinary alla prima effects in the painting of *Saint Anthony the Abbot and Saint Paul, the First Hermit* (ca. 1634, Prado, Madrid). Velázquez expressed himself with great piety, yet never giving into fanaticism or ostentation.

He never forgot his early training (from Pacheco in particular), but felt entirely free to insert symbolic and allusive elements into these works, as he does completely naturally in his depiction of the Temptation of Saint Thomas Aquinas (1631–32, Museo Diocesano de Arte Sacra, Orihuela). *Christ after the Flagellation Contemplated by the Christian Soul* (1628–29, National Gallery, London), once thought to have been realized after Velázquez's return, but undoubtedly influenced by the Italian works already in the royal collection and by his contact with Rubens, is also the only work with a mystical element: in his rendition of the spiritual communication between the child representing the Christian soul and Christ at the column, by means of a slender ray of light emanating from the child's heart to Jesus' head, under the vigilant gaze and bidding gesture of the Guardian Angel. How-

ever, by this time he was required to devote himself to a commission of a different nature, as one of the artists charged with decorating the new Buen Retiro summer palace being built to the east of Madrid at Olivares's instigation. A huge quantity of materials was ordered from Italy and all the painters in Madrid became part of the huge undertaking, from those closest to court circles to others recalled expressly for the purpose, such as Zurbarán, from Seville. Work began on the palace in 1634. It was to be a testament to the glory of the monarchy and of the sovereign, and thus Velázquez embarked on a series of equestrian portraits of Philip III and Philip IV with their queens and the heir designate destined to hang on the main walls of the Salón de Reinos (Hall of Realms), and a series of paintings of battles designed to underscore the triumphs of the monarchy on the others. These included his *Surrender of Breda* (1635, Prado, Madrid). No expense was spared in decorating the Hall of Realms; used for court entertainments and as a reception and throne room, it had to be able to hold its own with all the glittering courts in Europe. Meanwhile, life in the Velázquez family continued to be interwoven with his life as a court painter. One happy event was the marriage of his elder daughter, Francisca, to the painter Juan Bautista Martínez del Mazo, at the tender age of fourteen.

Velázquez was a traditionalist; having married his master's daughter, he now gave his own daughter in marriage to his own most esteemed pupil. As his family grew, so did his prestige at court, "rising in the ranks" from gentleman usher (a post that he could relinquish or pass on to his son-in-law) to

court constable and then to assistant to the royal wardrobe in 1636.

Between 1633 and 1636, while engaged with decorating the Retiro Palace, he was also asked to work on the Torre de la Parada hunting lodge near El Pardo. Philip IV kept quite a collection of Flemish work there, by Rubens and his workshop, some of which was rather substantial, like Ovid's *Metamorphoses*, and other lighter yet exceptionally skillful still lifes and hunting scenes. Velázquez was keen to fill the lodge with informal portraits of members of the royal family in hunting dress, along with their favorite animals, set against tranquil wooded or mountain landscapes. Yet again, he produced some marvelous paintings, his introspective approach brilliantly offset by the individual character of each of his figures. Given the theme, he was able to tackle the portraits without having to overly concern himself with etiquette, which meant that the finished works were more sensitive and simple than the official court portraits. It also provided him with another opportunity to try his hand at landscapes and, for the first time, with animals, at which he proved to be greatly skilled. The royal family were not surrounded by the trappings and trophies of nobility, but seen against very natural backgrounds, such as the Sierra de Guadarrama with its oak trees and snowy peaks (*Philip IV in Hunting Garb*, ca. 1635, Prado, Madrid; *Prince Baltasar Carlos as a Hunter*, 1635–36, Prado, Madrid; *Cardinal-Infante Ferdinand de Austria*, ca. 1633, Prado, Madrid). Velázquez also made several paintings of ancient mythological figures, which related to Rubens's cycle. However, unlike the rest of Europe, there

was very little mythological painterly tradition in Spain, and artists tended to engage much less frequently with this sort of subject. This is why Velázquez, who was in charge of the decorations, preferred to entrust them to foreigners, who were more likely to take themes of antiquity seriously. There was a close relationship between the culture of the Spanish painters and the literature of the Golden Age in which mythology tended to be treated in an oddly satirical vein by writers such as Góngora, Lope de Vega, and Cervantes, who were wont to describe the gods with the features of vulgar men and women. It is likely, too, that in the Counter-Reformation era, Spanish artists and authors would have turned to satire as a means of distancing themselves from paganism and demonstrating that they regarded mythological tales as mere entertainment. Allegory later served to restore the balance, imbuing every single element with meaning.

Velázquez's mythological works were very much in this literary genre, despoiling the mythological characters of their heroic stature (*Menippus*, 1639–40, Prado, Madrid; *Mars*, ca. 1641, Prado, Madrid). Naturally, he also carried out his normal duties as court painter, executing portraits not just of the royal family (*Don Baltasar Carlos with a Dwarf*, 1632, Museum of Fine Arts, Boston; probably the first royal painting he executed after his return from Italy), but also of other people in court circles. In particular, he made paintings of the court jesters in which he devoted great attention to the depiction of their characters, thus playing down their simplicity or physical deformities (*The Buffoon called "Juan de Austria,"*

ca. 1632, Prado, Madrid; *The Jester Cala-bacillas*, mistakenly called *Bobo de Coria*, 1637–39, Prado, Madrid; *The Buffoon Sebastian de Morra*, ca. 1646, Prado, Madrid).

Second Visit to Italy

Diego Velázquez set off again for Italy in November 1648. The years preceding this second trip were not easy ones, either for him or for the Spanish court. Political events had led to the fall of the count-duke (without any particular repercussions on Velázquez's artistic career, although it did bring him even closer to the king), political instability had been wrought by Portugal's recent secession and the French siege of Aragon and Catalonia (defeated by the king in the Battle of Lérida), there had been a number of tragedies in the royal family, with the death of the queen, followed by that of the king's sister Maria, and, finally, the cruelest blow of all, the death of the Infante Baltasar Carlos.

Velázquez's courtly duties multiplied, and he had to contend with a continuing lack of acceptance by the nobility. His father-in-law, Pacheco, died in 1639, and he was much involved with the task of decorating Alcázar Palace, where he frequently clashed with the architect, Gómez de Mora. After the death of the latter (1648), he became solely responsible for the palace decoration. His second trip to Italy could thus not have come at a better time. This time the king himself had sent him on a special diplomatic mission to Pope Innocent X. He was specifically entrusted with purchasing works of art, original paintings, and antique statues, both Roman and Greek, of which there was an ample supply in and

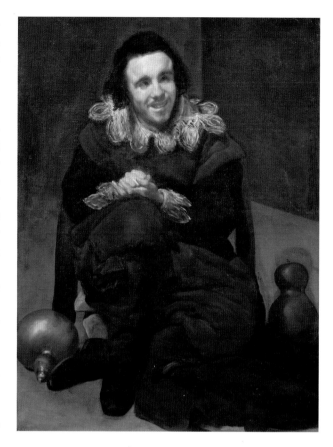

The Jester Calabacillas, mistakenly called Bobo de Coria
1637–39
Museo Nacional del Prado, Madrid

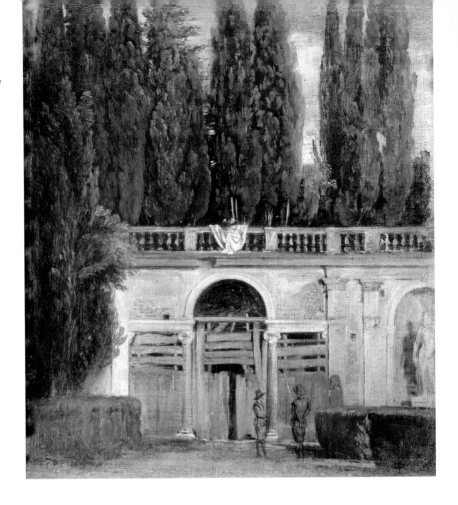

The Medici Gardens in Rome (Façade of the Grotto-Loggia)
ca. 1630
Museo Nacional del Prado, Madrid

around Rome. He was accompanied by Don Jaime Manuel de Cárdenas, who had been charged with meeting Philip IV's new bride-to-be, Mariana of Austria, daughter of Emperor Ferdinand III and the Empress Maria, Infanta of Spain, in Trent.

He disembarked at Genoa and made his way to Milan where, totally disinterested in the queen's triumphal entry, he devoted his time to admiring the city's marvelous works of art and sculpture, including Leonardo's Last Supper and, according to Palomino, "all the paintings and art that there are in that city." After a visit to Padua, he went on to Venice to renew his acquaintance with the masterpieces that had helped to shape his artistic development twenty years earlier. None of the artists working in Italy at that particular time were in a position to teach him anything, so he turned again to the artists of the past. He also acquired canvases by Tintoretto and Veronese, and a number of portraits. He met Agostino Mitelli and Michelangelo Colonna in Bologna, both well-known fresco painters, with a view to inviting them to return to Spain with him. The king's special mandate gained Velázquez entry to much wider noble Italian circles than on his previous trip. He also went to Florence, which he had bypassed on his earlier visit, and then on to Modena where he was a great favorite of the duke's. During his time in the dukedom, he took the opportunity to see Correggio's celebrated work in the dome of the cathedral in Parma, and various paintings by Parmigianino. Before going to the Papal court in Rome, he made a slight diversion to Naples, where he was able to renew his acquaintance with the Count of Oñate, the viceroy asked by Philip IV to "assist widely and profusely" with anything Velázquez might need to help him carry out his mission. He spent the next few months traveling around the peninsula, looking at old masters in an endeavor to choose the best to take back to the king. He also took up his introductions to the various courts, not to make portraits, but to discuss art and purchase great works. During the first few months of this journey, therefore, he was traveling in the guise of an interested collector and diplomat, and did not lift a paintbrush until he got to Rome. He stayed in Rome for a whole year of his two and a half years' absence from Spain; his position as painter to the king gave him a certain freedom, and he was able to prolong his stay despite the king's entreaties for him to return to court.

He began to paint again once he got to Rome in around spring 1650, probably because he had a secure base. He started with a handful of portraits (*Juan de Pareja*, 1650, Metropolitan Museum of Art, New York; *The Lady with a Fan*, ca. 1640, Wallace Collection, London), some of which merely consisted of sketches, culminating in the wonderful portrait of Pope Innocent X (1650, Galleria Doria Pamphilj, Rome). A year in the Eternal City was enough to gain him admittance to the most privileged artistic circles, the Accademia di San Luca and the Confraternity of the Virtuosi at the Pantheon, but it also sparked an amorous liaison and the birth of a child, which is thought to be the reason for his lengthy delay in returning to Spain, despite the king's repeated requests. He also made contact with Pietro da Cortona in Rome, and tried to persuade him to go to

Madrid, but to no avail, unlike his efforts with Mitelli and Colonna in Bologna, which eventually bore fruit.

The Final Glorious Years at Court

On his return to Madrid, in June 1651, Velázquez took with him the paintings and sculptures he had acquired on behalf of the king. His mission had been geared to Philip's wish to decorate the new royal palace, on which work had continued during his two-year absence. The king was so delighted with Velázquez's spoils that he decided to appoint him *aposentador mayor*, or palace marshal, in June 1622. His appointment was proposed by the royal council, despite the fact that this meant leapfrogging over various important courtiers and the veto of five members of the commission. This also meant that his palace duties became even more plentiful. He was completely immersed in court life and was responsible for the king's travel and movements, arranging his accommodation, organizing his wardrobe, his tableware, and ceremonial and festive decorations of all kinds, not to mention protocol—a major-domo for all intents and purposes. His duties during 1656 included hanging some of the paintings at the Escorial, revealing himself to be a gifted museologist. Although all this cut into his painting time, Velázquez nonetheless managed to produce masterpieces such as *Las Hilanderas*, also known as *The Fable of Arachne* (ca. 1657, Prado, Madrid), and the series of four mythological paintings for the Alcázar Palace, of which the only remaining one (*Mercury and Argos*, ca. 1659, Prado, Madrid) clearly shows the Italian influence.

During his final years, his more pressing palace duties forced Velázquez to cut down on his painting, and this may have been the reason for his involving other artists in his work. They did not, however, prevent him from making some stunning portraits of the royal family, in which he had perfected the technique of virtually dematerializing his colors through his brushstrokes. In addition to the series of portraits of the young queen and the aging king, who was growing increasingly anxious about the fate of his kingdom (*Philip IV of Spain*, ca. 1656, National Gallery, London and 1656–57, Prado, Madrid; *Mariana of Austria*, ca. 1652, Prado, Madrid), his final masterpiece is undoubtedly the painting called *The Family of Felipe IV*, now known as *Las Meninas* (ca. 1656, Prado, Madrid), a reference to the maids of honor who served the Infanta Margarita. The painting was hugely successful over the following centuries, studied by Goya, who drew inspiration from it for the official portrait of Charles IV and his family, and later by Picasso, for whom it inspired some sixty paintings. The particularly interesting series of portraits of young infants also belongs to this period, which enabled Velázquez to express the delicate grace of infancy along with the vein of melancholy that inhabits all real children (*Infanta Margarita Teresa in a Pink Dress*, ca. 1653–54, Kunsthistorisches Museum, Vienna; *Prince Felipe Próspero*, 1659, Kunsthistorisches Museum, Vienna). All through his long years at court, Velázquez had nursed a desire for noble recognition. Following the debate over the arts, like other artists, he wanted to compete with those of noble birth, and see his exceptional intellectual and creative ability

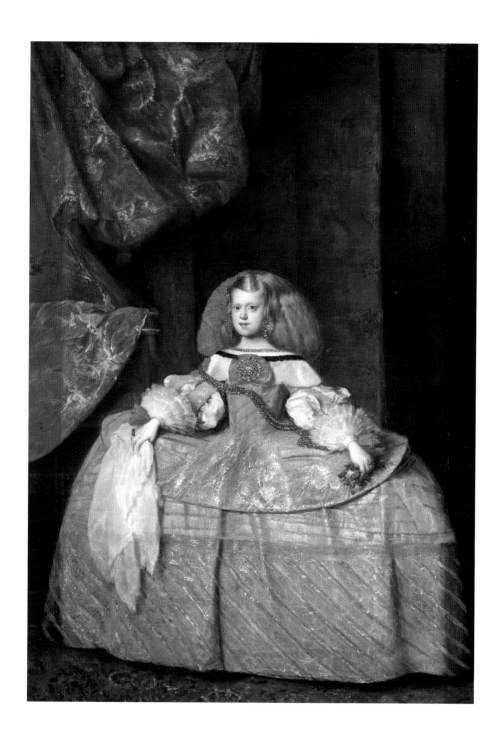

Mercury and Argos
ca. 1659
Museo Nacional del
Prado, Madrid

recognized. For some time, while in the service of the king, he had grown dissatisfied with the respect in which his art was held at court or his lofty commissions—what he really wanted was to be made a knight of the Order of Santiago, from which painters, their families, and anybody engaged in manual work were normally barred. It was only after a lengthy process that he was accepted into the Order, having been able to demonstrate some noble antecedents and receiving a dispensation from the pope. Finally he got his moment of glory, becoming a knight on June 12, 1658. Two years later, after his return from a gathering on the Faroe Islands that he himself had organized to celebrate the engagement of the infanta, Velázquez died in Madrid on August 6, 1660, after a short illness. His funeral, held with great pomp the following day, was the final proof of just how high he had risen.

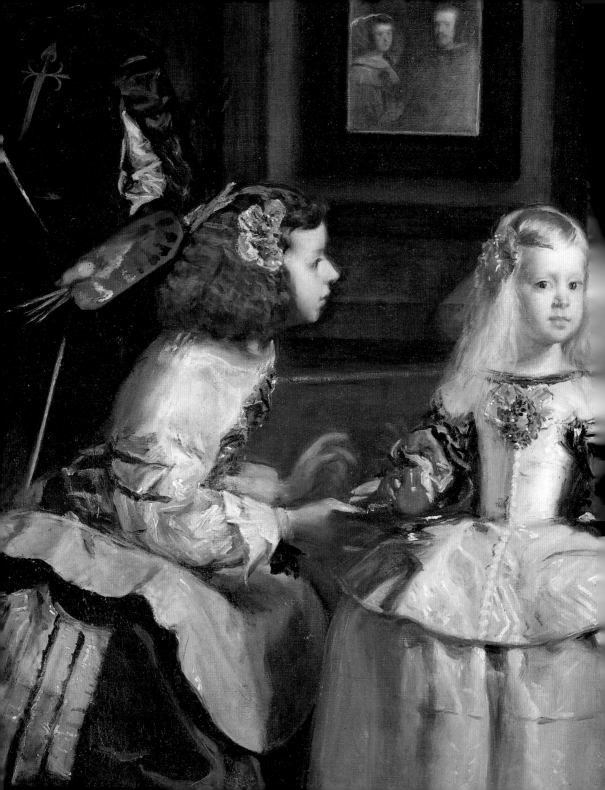

WORKS

Kitchen Maid with the Supper at Emmaus (La Mulata)

ca. 1617–18

Oil on canvas, 55 x 118 cm
National Gallery of Ireland, Dublin

The *Kitchen Maid with the Supper at Emmaus* is an early Sevillan "picture within a picture," in which the double image serves a precise educational purpose. The subject matter probably derives, through printed copies, from Pieter Aertsen's Flemish paintings of roughly three-quarters of a century earlier. The result is a *bodegón*, a still life in the Spanish style depicting a simple interior kitchen scene with everyday objects, accompanied by a representation of the Supper at Emmaus, seen in this case through a window in the far background. The use of the window device indicates that the double scene represents an apparition (the scene corresponds to the excerpt from the Gospel of Luke on the risen Christ—recognized when he broke bread for the disciples at Emmaus on the evening of the Day of Resurrection) and the unveiling of the *fenestraliter* mystery. Saint Teresa believed that prayer took transcendence into immanence "through a window." Velázquez was undoubtedly well acquainted with the writings and spirituality of Saint Teresa of Avila, whom the artist has also chosen to include in the painting, lending an air of unsteadiness to the various objects on the table in the foreground that make up the admirable still life. On one hand, they almost seem to be animated by an invisible breath, which could be interpreted as a divine presence, which in turn determines the air of surprised concentration in the woman observing these objects ("caught" in the act of taking the jug); and on the other, it is a reminder of Saint Teresa's saying, "Don't be sad when obedience draws you to involvement in exterior matters. Know that if it is in the kitchen, the Lord walks among the pots and pans helping you both internally and externally!"

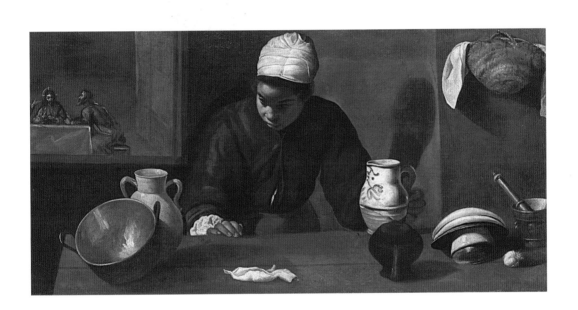

An Old Woman Cooking Eggs

1618

Oil on canvas, 100.5 x 119.5 cm
National Gallery of Scotland, Edinburgh

Velázquez embarked on his masterful *bodegónes* during the Golden Age, when religious, historical, and mythological paintings were enjoying far greater popularity. Depictions of simple environments, such as kitchens or taverns (in fact, *bodegónes*), with shabbily dressed people engaged in decidedly ordinary activities were regarded as inferior and without merit. But it all depended on the way in which such scenes were represented, as Francisco Pacheco, who was a conservative upholder of historical artistic tradition, said in defense of the genre (or perhaps of his son-in-law, Velázquez): "Well, then, are *bodegónes* not worthy of esteem? Of course they are, when they are painted as my son-in-law paints them ... they are deserving of the highest esteem". Executing this painting caused Velázquez to become enormously interested in the various components of genre painting, such as the setting, the human figures, and the objects, each of which is treated with the same dignity, all laid before the observer in a well-thought-out use of light, or tenebrism, harnessing the light from above to valorize each individual element for its particular shape, color, and tactility. In the foreground a battery of utensils sits on top of a slightly inclined surface, in the Nordic manner, so that the objects are viewed from above. It is reminiscent of still lifes by Zurbarán, in which the objects and the fruits and vegetables are often placed on a single plane, engaging the eye with the beauty and precision with which each individual object is singled out through the exact representation of its particular characteristics. Time stands still: the old woman frying eggs and the boy are not looking at each other, but the diagonal approach to the space brings their hands close to each other, one holding a spoon and the other holding a gleaming glass bottle, thus rounding off the composition.

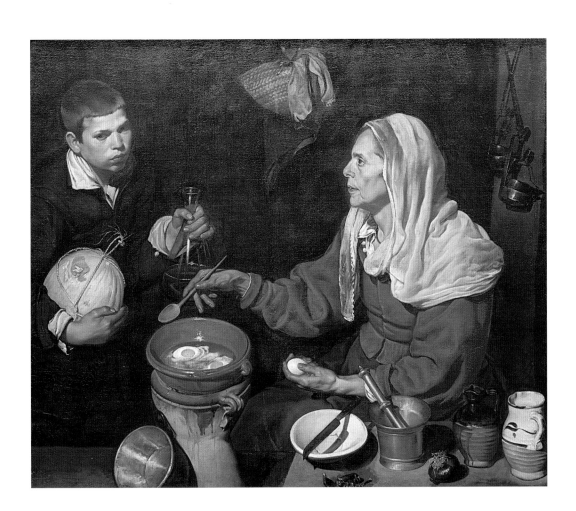

Saint John the Evangelist on the Island of Patmos

ca. 1618

Oil on canvas, 135 x 102 cm
The National Gallery, London

This was painted as a companion piece to *The Immaculate Conception* (1618–19, National Gallery, London) and is one of the paintings executed shortly after Velázquez's marriage to Juana Pacheco. He has tackled a religious subject into which he has incorporated decidedly naturalistic elements and has achieved great mastery of volume and plastic rendering through his use of chiaroscuro and his knowledge of contemporary sculpture. Following the tradition of bringing the observer closer to the sacred work through attention to detail and the naturalistic rendering of the figure, the painting shows Saint John in exile on the island of Patmos, sitting on a rock near a plant, pen poised to record his vision of the Apocalypse. The rather shadowy landscape elements enable us to identify the wild place as an island. In complete chromatic and volumetric contrast, the eagle (his iconographic attribute) appears on his right, while the fabric of his cloak flows in folds on his left. He is pictured gazing soulfully and raptly at his inspiring vision: the woman clothed in the sun, later immortalized in chapter 12 of the Apocalypse. Tradition has it that Saint John was exiled on Patmos in his later years, but Velázquez has chosen to represent him through the iconography of the youngest of the twelve apostles. Some art historians believe his face to be a self-portrait, given its similarity to the supposed self-portrait in the Prado, although the artist's decision not to depict the full face means that this cannot be proved with any certainty.

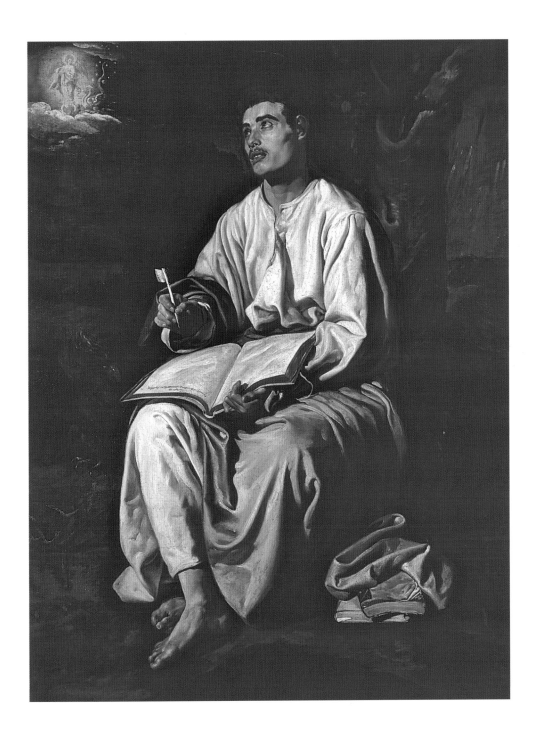

The Waterseller of Seville

ca. 1620

Oil on canvas, 105 x 80 cm
Wellington Museum, Apsley House, London

This is one of Velázquez's greatest Sevillan masterpieces. It was given to Juan de Fonseca, a canon of Seville Cathedral, in 1623. He had joined the court of Philip IV as a *sumiller de cortina*, looked after the palace chapel, and was responsible for making sure the curtain hiding the king from his courtiers was pulled right across. The work bears all the hallmarks of a genre painting (an everyday subject and the precise execution of the still-life elements), and may contain an allegory, the most popular interpretation of which refers to the three ages of man. The wise figure of the waterseller is in the foreground: an elderly incarnation of experience, offering the font of wisdom to the younger man in the background. The figure of a youngish man emerges from the shadows between them, drinking greedily from an earthenware mug: this is the image of thirst or, according to the allegory of the three ages, represents mature man acquiring knowledge. The vertical format of the composition enables depth to be achieved through skilled use of light in a luminous spiral that serves to unify the scene, shifting from the large amphora in the foreground to the jug on the table, and on to the heads of the three people.

Light is also harnessed to pick out the finest details, as in Caravaggio and in Flemish engravings. The observer's eye is drawn to the marvelously fresh beads of water forming on the earthenware amphora, the splendid jug, the transparency of the glass goblet (containing a fig intended to flavor the water with "salutary virtue"), the earthenware mug from which the man at the back is drinking, and the wrinkles on the old man's neck and the way in which his clothes are rendered.

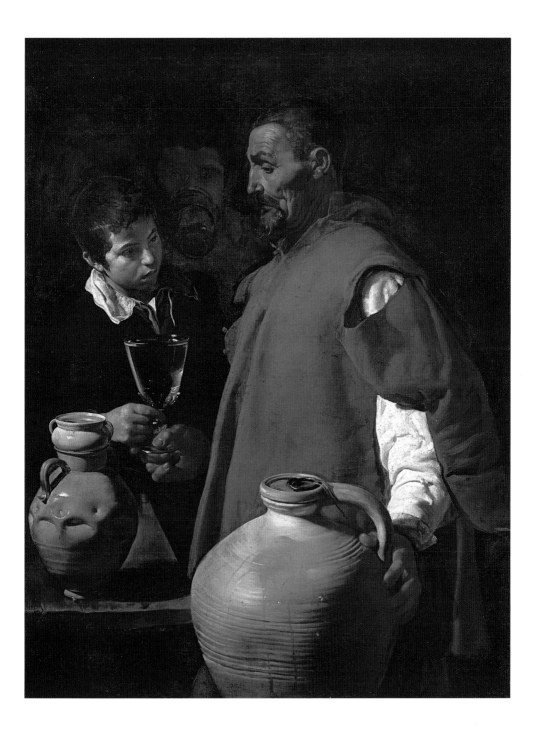

Adoration of the Magi

1619

Oil on canvas, 203 x 125 cm
Museo Nacional del Prado, Madrid

The painting is likely to have been executed for the Jesuit Brotherhood in 1619: the painter has written a date on the stone below the group with the Virgin and Child (the first instance of this in his work); if the date really is 1619, the painting would have been made a year after Velázquez's marriage to Juana Pacheco, around the time their first daughter, Francisca, was baptized. It is a devotional work that would have been appropriate for practitioners of Saint Ignatius of Loyola's spiritual exercises, who were required to observe it using all five senses and dispensing with any idealization. Most critics believe the *Adoration of the Magi* to be a family portrait in the manner of Caravaggio, using real models for the subjects and making liberal use of tenebrism, or chiaroscuro. The Virgin is depicted holding a heavily swaddled Christ child (actually a portrait of his daughter Francisca) in her hands, which are those of a woman used to driving a plow or even to "taking the bull by the horns." She is generally identified as the painter's wife, Juana Pacheco. Balthazar, the black king, could well be a portrait of one of the artist's brothers or a servant. In accordance with the advice of Saint Ignatius, the king's magnificent embroidered collar is in stark contrast with the modest clothing of the other Magi. The middle-aged king is clearly Velázquez's father-in-law and master Francisco Pacheco, while the one kneeling in the foreground could well be a self-portrait. Finally, the glimpse of the twilit landscape just enables us to make out a cleverly silhouetted shed wall and also gives us a foretaste of what this great landscape artist would be capable of achieving, experimenting with light and shade.

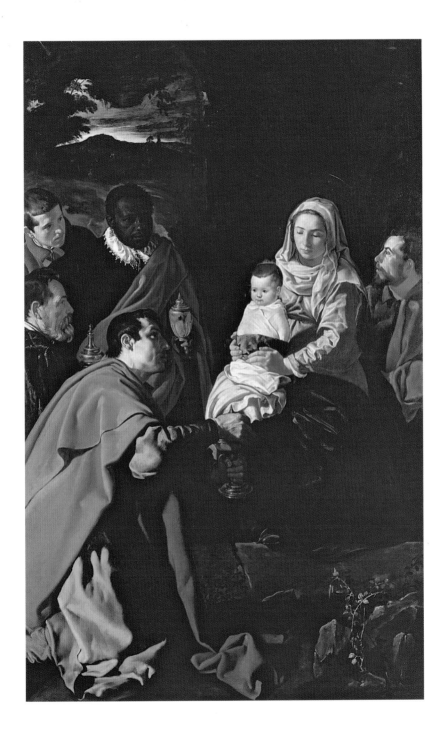

Adoration of the Magi
(details)

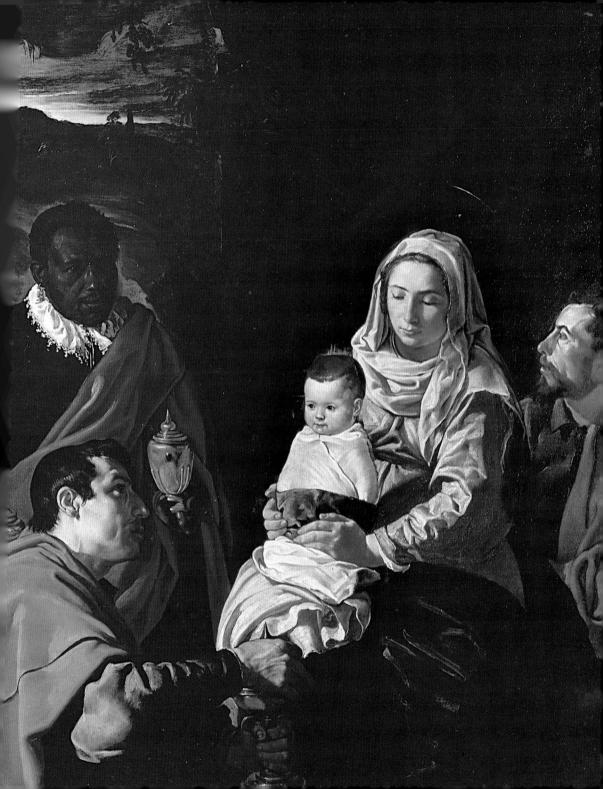

Christ in the House of Martha and Mary

1618

Oil on canvas, 60 x 103.5 cm
The National Gallery, London

The device of the "picture within a picture" characterizes this painting, and the religious allegory in the still life with figures is clear. Velázquez was the supreme master of double paintings, which the Flemish artists had experimented with during the fifteenth century and the trend continued over the following two centuries. Like theatrical motifs, in which new threads become interwoven with the main story, the elements that "redouble" the motif in the foreground are the key to unlocking the painting, leaving its meaning hanging and open to interpretation. In this painting, which is in the National Gallery in London, it is hard to tell whether the scene in the background is a painting, a window, or a mirror; what matters is its relationship to the figures that round off the simple still life. The religious scene in the background portrays the passage from the Gospel according to Luke (10: 38–42), with Christ sitting in the house of Martha and Mary, being welcomed and listened to by Mary, who is sitting at his feet like a disciple listening to her master, while Martha is busy with preparations for their guest, and asking Christ to tell her sister to give her a hand. He replies by gently telling her not to fret about what there is to be done, but to listen to God first and foremost. The tiny picture in the background bears all the traditional iconographical hallmarks of this episode, while the old woman in the foreground (the same model as in *An Old Woman Cooking Eggs*), is exhorting the young woman busy pounding garlic in the mortar to heed the Gospel message.

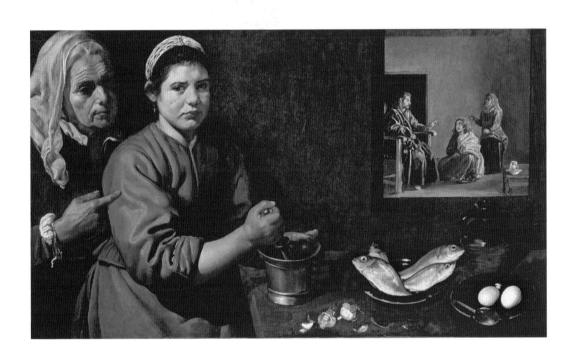

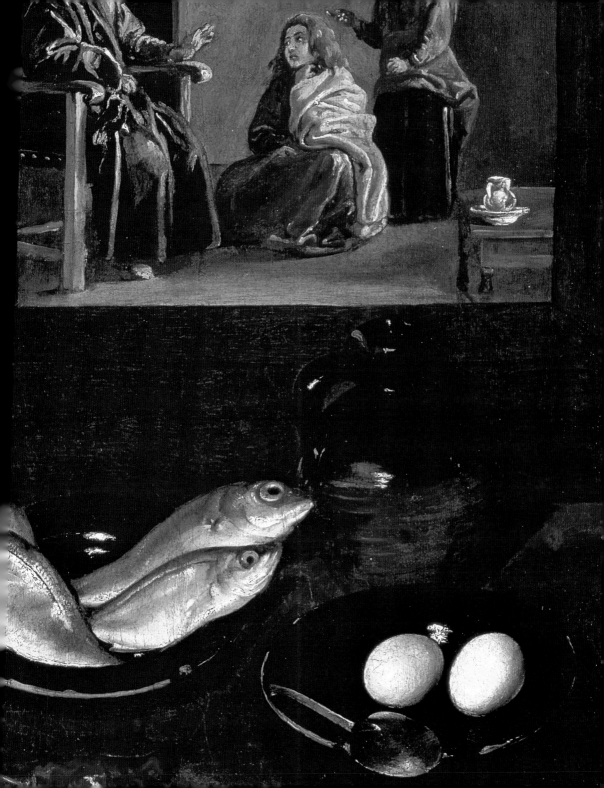

Francisco Pacheco

1619–22

Oil on canvas, 40 x 36 cm
Museo Nacional del Prado, Madrid

Allende-Salazar first identified this as a portrait of Velázquez's father-in-law and master in 1925, which would tie in with his habit of using members of his family as life models during his early career in Seville. Although there is no concrete proof that this is indeed a portrait of Francisco Pacheco, the postulation is supported by its extreme similarity to the middle-aged king in *Adoration of the Magi* (1619, Prado, Madrid), which contained figures modeled on various relatives. Francisco Pacheco was a painter and a leading writer of tracts. Diego Velázquez joined his workshop in 1610 and married his daughter Juana in 1618, a sign of the respect and fondness in which her father held him. This painting is one of his first autonomous portraits and is characterized by two elements in particular: its psychological insight, which was to become one of the hallmarks of his portraiture; and the accentuation of one single fashionable element, the splendid "millstone" ruff. Velázquez's early stylistic motifs are evident in the plastic rendering and definition of his brushstrokes, which are still informed by his training in Seville. He is clearly also becoming fascinated by lighting effects, again experimenting with chiaroscuro to accentuate the bust against the background, and a limited palette that contrives to focus all the light on the fancy white ruff, before glancing away and onto the face of the sitter, and in the definition of the shadowy background.

Saint Ildefonso Receiving the Chasuble from the Virgin

1623

Oil on canvas, 166 x 120 cm
Museo de Bellas Artes, Seville

This is a devotional painting to the Virgin Mary, executed in Seville following Velázquez's first visit to Madrid. Nothing is known about the circumstances surrounding the commissioning of the painting, which was in the cloister of the church of Saint Anthony in Seville before being recognized as a Velázquez in the eighteenth century, when it entered the collection of the Museo de Bellas Artes in Seville. It is informed by a seventh-century Toledan legend that Saint Ildefonso, the Bishop of Toledo originally from Seville, had a vision of receiving a splendid white chasuble as a gift from the Virgin Mary as a sign of recognition and gratitude for his writings in defense of her virginity. Velázquez has clearly been influenced by El Greco in the rendering of this religious subject, although he also takes his own inimitable spin on it. Clearly to be able to read the supernatural event (the apparition of the Virgin) in tandem with the real, natural depiction of the kneeling saint, the composition has been executed on two different, almost uncommunicating planes, linked by Mary's hands holding the chasuble over the figure of Ildefonso, who is seen on his knees and in profile, seemingly unaware of the enveloping vision other than on a spiritual level. The chasuble is not white, as described in the ancient legend, but red, resonating with the warm tones of the painting as a whole. The upper portion of the composition, containing the apparition of the Virgin, seems to have been left incomplete, thus off-setting the rather "unfinished" figures of her companions in the clouds. They are likely to be saints (note the olive branch in the hand of the figure on the far right, which connotes the state of martyrdom), bearing the features of local Sevillan girls.

Gaspar de Guzmán, Count-Duke of Olivares

1624

Oil on canvas, 203 x 106 cm
Museu de Arte, São Paulo

This is the first full-length portrait of Don Gaspar de Guzmán de Olivares. It was to be followed by others commissioned by the duke as a form of self-celebration. It is a court portrait designed to highlight the sitter's powerful, bulky physique, almost to the point of ostentation. The first hint and indication of his political importance lies in the position of the hands, one gripping the edge of a small table, the other resting on the hilt of his sword, a crucial allusion to his noble status. During the Golden Age of Spanish painting, and in Velázquez in particular, the presence of a table in the vicinity of a portrait denotes majesty and justice, and is a feature of all the royal portraits but of only two others: this one and the portrait of the magistrate Don Diego del Corral y Arellano (ca. 1631, Prado, Madrid). Other elements underscore the subject's social standing to even greater effect: the riding spurs hanging from a golden chain (denoting his position as *caballerizo mayor*, or master of royal stables), the major-domo's key gleaming against the dark clothing, painted at the same angle as the magnificent, heavy gold chain and the red cross of the Order of Calatrava embroidered on his chest, replaced in later works by the green cross of the Order of Alcántara.

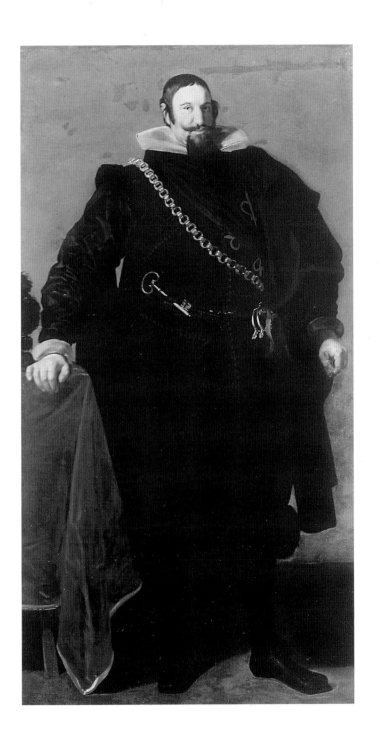

The Infante Carlos

1626–27

Oil on canvas, 209 x 125 cm
Museo Nacional del Prado, Madrid

Difficult as it was to identify the subject of this portrait, given the powerful similarity between Philip III's sons, this painting is recognizable as the Infante Don Carlos of Spain, and was probably executed between 1626 and 1627, when he would have been about twenty years old. He was the second son of King Philip III and was a lover of the arts, wrote poetry, and painted—at which he was particularly gifted. He is seen here in an elegant pose, definitely less stiff and more at ease than might have been expected of a sovereign.

Velázquez has focused on some of the precious details that define his high social standing: the broad, stiff, starched collar—which was the fashion during the reign of Philip IV, taking over from the great "millstone" ruff of Flemish origin—which has been delicately and beautifully rendered, as have the treatment of the face and the details of his hairstyle; the golden fleece that hangs from a dark ribbon in tone with his clothing and held down by a superb gold shoulder chain, is a small yet essential detail almost obscured by the heavy chain that serves to underscore the infante's importance. The treatment of the hand loosely holding the empty glove by one finger is delicately masterful, and echoed by the faintly crooked little finger. The choice of composition is particularly interesting, showing the subject against a neutral background that becomes paler at foot level in order to give prominence to the elevation of the figure.

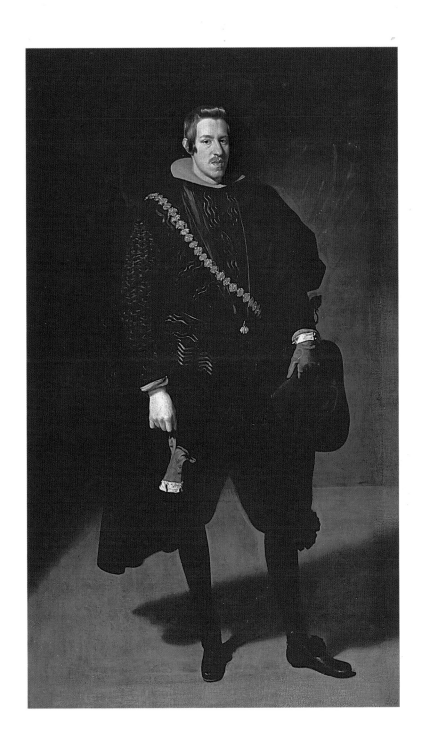

The Temptation of Saint Thomas Aquinas

1631–32

Oil on canvas, 244 x 201 cm
Museo Diocesano de Arte Sacro, Orihuela

This is a religious painting, drawn from the hagiography of the Dominican priest Saint Thomas Aquinas. It portrays the moment immediately after his desperate battle against temptation and shows the exhausted saint collapsed in the arms of an angel who has come to support him. This is not a rendition of the drama itself, but the tranquil epilogue to an episode that involved Saint Thomas being imprisoned by his family in their property at Roccasecca and being tempted by a woman instructed to use all her powers of seduction to persuade him to abandon his decision to devote his life to the Dominican Brotherhood. The work is indicative of the artist's familiarity with Italian, Roman, and Venetian compositional methods, and is laid out in an intersecting diagonal format, enabling all the narrative elements to be read and completely understood. The saint's iconographical attributes (his study tools) lie in the bottom right of the picture, and our eye is then drawn towards the white belt, the symbol of chastity, as the unsuccessful temptress makes off in the background. She has been rendered with particular dynamism, in contrast to the serene foreground scene. The other diagonal places the image of the saint in line with the chimneypiece. The glowing ember is still smoking and is aligned with the mark on the wall near the great fireplace, a cross traced with the same ember. At the intersection of the diagonals are the delicate faces of Thomas with his tonsure, his head encircled with light rather than a halo, and the angel sent to comfort him.

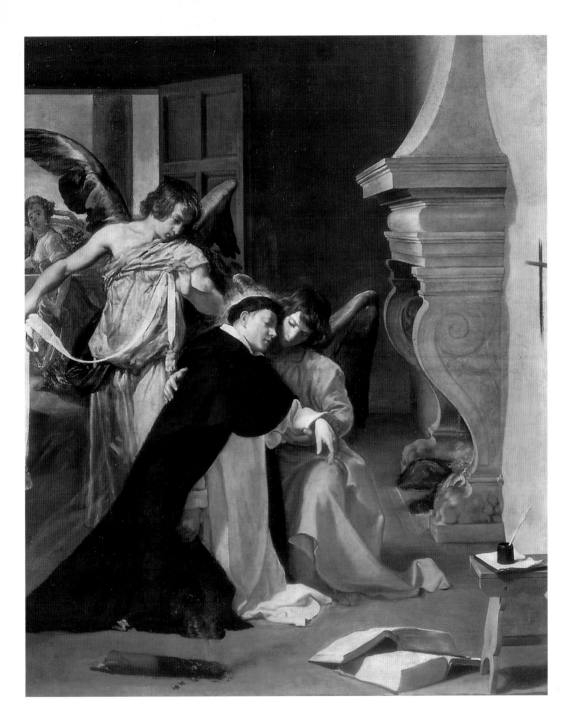

The Triumph of Bacchus, or The Drinkers

1628–29

Oil on canvas, 165 x 225 cm
Museo Nacional del Prado, Madrid

This painting may well have been inspired by Rubens, and was probably completed in 1629, when there is a record of a payment of one hundred ducats to Velázquez. Variously known as *The Triumph of Bacchus* and *The Drinkers*, it is clearly parodying the myth, showing Bacchus as a young male nude simply playing the part of the God of ancient mythology, looking rather unconvincing despite the traditional iconographic attributes.

This Bacchus even appears to be distracted while placing an ivy wreath on the head of a man kneeling devoutly before him—a process made to look like a profane transposition of a liturgical rite. The position of the latter emphasizes his gaucheness, underscoring his inferiority and deference to Bacchus. There is a clear reference to Caravaggio in the depiction of Bacchus, who belongs to the same category of young men making ambiguous gestures. Other figures are more reminiscent of Ribera, the face and expression of the young man on the left of Bacchus in particular. He is seen full face, grinning and laughing towards the observer, helping to turn the solemnity of the ritual into an amusement between *picaros*, a send-up of the myth. Partly hidden by a cloth, almost as if they were an offering to Bacchus, the jug and glass bottle, of which only the bottom is seen, make up a marvelous still life at his feet, the play of reflections enlivening the volumes of the objects.

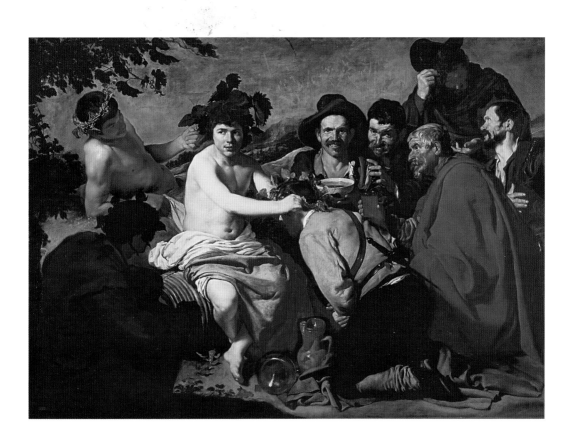

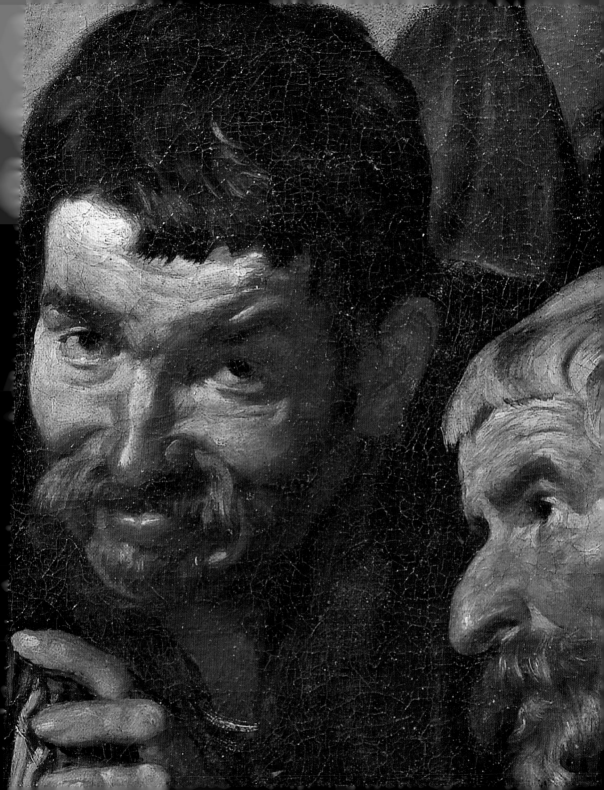

The Forge of Vulcan

ca. 1630

Oil on canvas, 223 x 290 cm
Museo Nacional del Prado, Madrid

This painting was executed during Velázquez's stay in Rome in 1630 and is likely to have been influenced by the work of Guido Reni and by classical statuary. It represents the visit of Apollo to Vulcan's forge to inform him of his wife Venus's betrayal of him with Mars, the god of war, while Vulcan was actually in the process of forging Mars's armor. It was probably a companion piece to *Joseph's Bloody Coat Brought to Jacob* (1630, now in the Monasterio de San Lorenzo, El Escorial), a biblical subject that enabled him to tackle the themes of deceit and betrayal. The myth has been depicted as an everyday scene, thanks to the skillful treatment of the characters' expressions of surprise and incredulity at Apollo's news. The dark atmosphere of the forge is relieved by the expedient of a window opening out onto a landscape as a backdrop to the sun god, creating a skillful play of light on the blacksmiths, who seem rooted to the spot by his words. Apollo's head is framed by an aureole, the main light source in the gloomy forge, and his mother-of-pearl skin, like the rest of his body, is extremely delicate. The composition is full of superb still-life elements: the armor being forged by Vulcan is of a modern kind (and its gleam constitutes the third luminous element in the composition, along with Apollo's aureole and the light of the little flames dancing in the fireplace), the objects on the mantelpiece—the small, beautifully crafted vase, which chimes with the blue of Apollo's sandals and the patch of sky behind him—bring a precious note of color to a largely earth-toned composition. Finally, perhaps, the most academic element in the entire composition is the back view of the blacksmith, whose physique is reminiscent of a great many heroic statues of old, although he has been given a modern coiffure and sideburns that contrast with his perfect musculature.

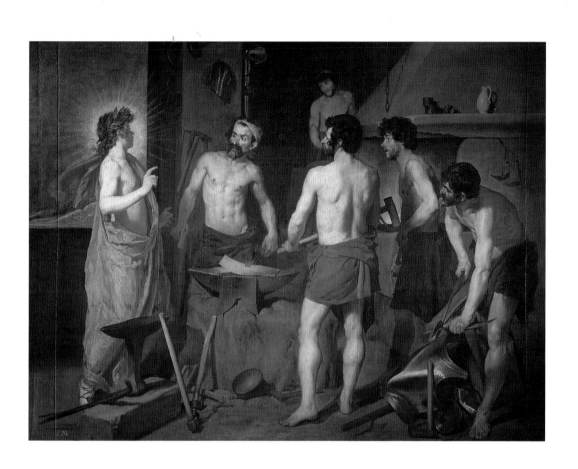

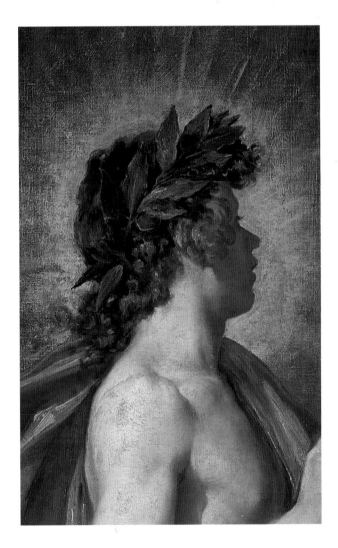

The Forge of Vulcan
(details)

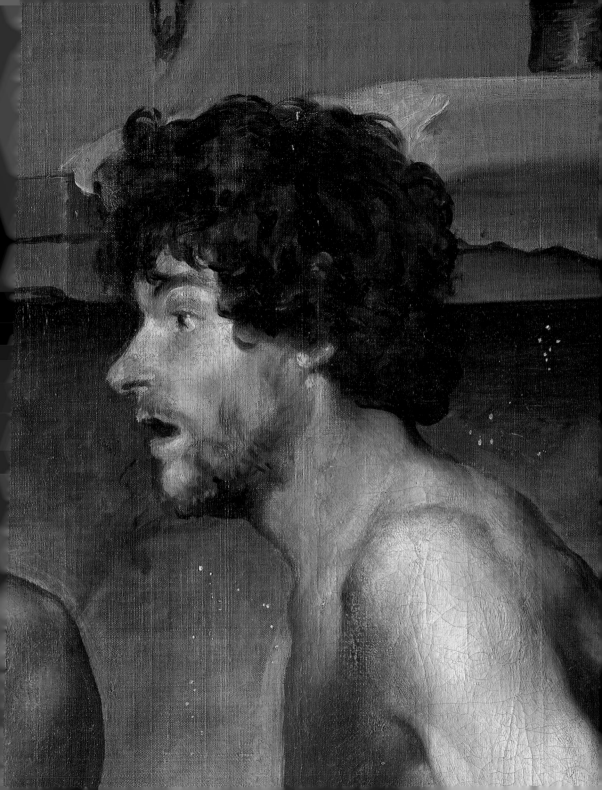

Joseph's Bloody Coat Brought to Jacob

1630

Oil on canvas, 223 x 250 cm
Monasterio de San Lorenzo, El Escorial

Possibly painted as a companion piece to _The Forge of Vulcan_ (ca. 1630, Prado, Madrid), this picture could well represent the allegory of calumny or deceit, and tells the biblical story of Joseph, son of Jacob. Joseph was sold by his jealous brothers, who then took his bloodied tunic to their father, to try and convince him that Joseph had been attacked and killed by a ferocious animal. The painting was executed in Rome in 1630 and was subsequently acquired by Jerónimo de Villanueva for the royal collections. The spatial composition is similar to its pendant: an enclosed space with a window on one side, overlooking a landscape. This window, however, is larger with fresh notes of color, designed to open out the space and light from the main scene. The checkered floor is unusual in Velázquez, and is informed by the rules of perspective he would have absorbed in Italy, an effect heightened by the staff lying abandoned on the floor facing the opposite way but following the same line of direction as the young men's shadows.

The dramatic rendition of Jacob's despair when confronted with the bloodied tunic resembles a stage set, the protagonists expressing their feelings rather theatrically: the young man pretending to cry turning away and raising his right hand to his face—worthy of the academic paintings of Bologna or Rome—and the elderly father throwing up his arms. The little dog, a traditional iconic symbol of loyalty, is barking at Joseph's lying brothers, as if he were able to sniff out their betrayal. It provides a lively note, serving to underscore Velázquez's painterly skills, and is a detail that he sometimes repeated in other works.

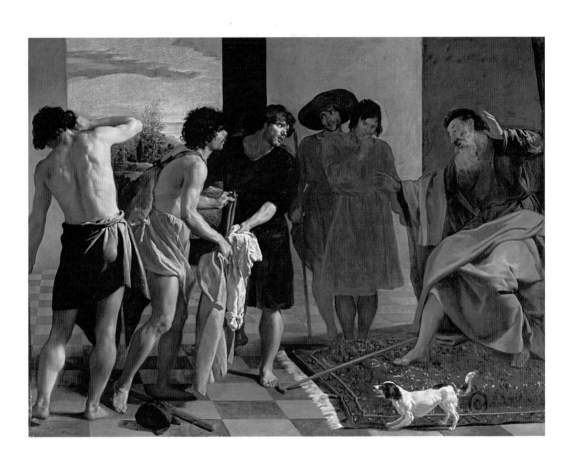

The Lady with a Fan

Oil on canvas, 95 x 70 cm
The Wallace Collection, London

The identity of this melancholy-looking woman is not known, but she makes one of Velázquez's most enigmatic and fascinating informal portraits. Art historians have noted a resemblance to the painter's daughter Francisca Velázquez, who posed for her father on several occasions (she may well also have been the model for *The Needlewoman* in the National Gallery in Washington). The plunging neckline of her bodice suggests that the picture may have been painted only slightly prior to 1639, since a royal decree had been issued in Spain in April of that year banning low-cut necklines, a French-led fashion, in an attempt to improve public decency. Prostitutes were the only women permitted to dress in such a way, but the rectitude of the woman in the portrait seems unquestionable given the splendor of the corona of the rosary on her left arm from which a cross hangs, along with a religious medal on a lilac ribbon.

The woman is also making a rather modest gesture with her left hand, as if to cover her décolleté with part of her mantilla. This very gesture could, however, also be interpreted as an attempt to draw attention to it, making the painting more suggestive. The enigma is made even more puzzling by the delicate, simple black mantilla, a sign of widowhood, and the half-open fan might suggest a memorial portrait, thus putting a different spin on the picture and on the identity of the woman; perhaps she is the woman in Rome with whom Velázquez fell in love and caused him to delay his return from Italy.

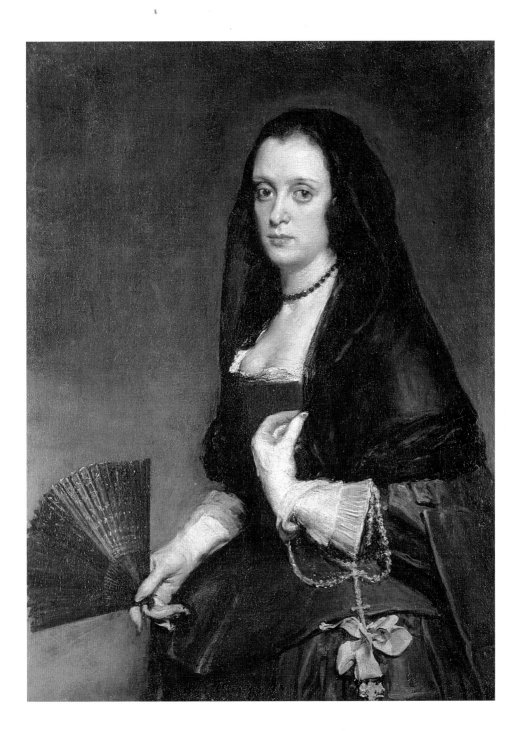

Christ Crucified

ca. 1632

Oil on canvas, 248 x 169 cm
Museo Nacional del Prado, Madrid

Legend has it that this crucifixion, known as the San Placido crucifixion, was commissioned by King Philip IV as a votive offering in penance for a romantic dalliance, and later donated to the Benedictine nuns at the Convent of San Placido in Madrid. The painting remained in the convent until the late eighteenth century, after which it passed through several hands before entering the Prado (1829) from the collections of the Duke of San Ferdinando, heir to the Countess of Chinchón. Christ's "Apolloesque" body, its pale flesh contrasting with the dark background, conforms to the classical canons Velázquez would have encountered and mastered during his first trip to Italy. The fine white loincloth tied across his pelvis is also a clear reference to classical Italian models. These new skills, which were immediately put into practice, tie in with his early Sevillan training: Christ's feet rest on a broad plinth, to which both are nailed, in line with the iconography recommended in Francisco Pacheco's treatise on the art of painting. Pacheco was an artistic arbiter for the Spanish Inquisition, and his rules were underpinned by the views of numerous Church Elders. However, the artist's decision to include the inscription bearing Jesus' sentence in all three languages (Hebrew, Latin, and Greek) rather than the more common abbreviated INRI is particularly erudite and unusual. The fact that this painting shows the dead Christ on the cross is traditionally said to have been because Velázquez was displeased by his rendering of the bowed head and thus, in a fit of irritation, covered over half the face with drooping locks of hair.

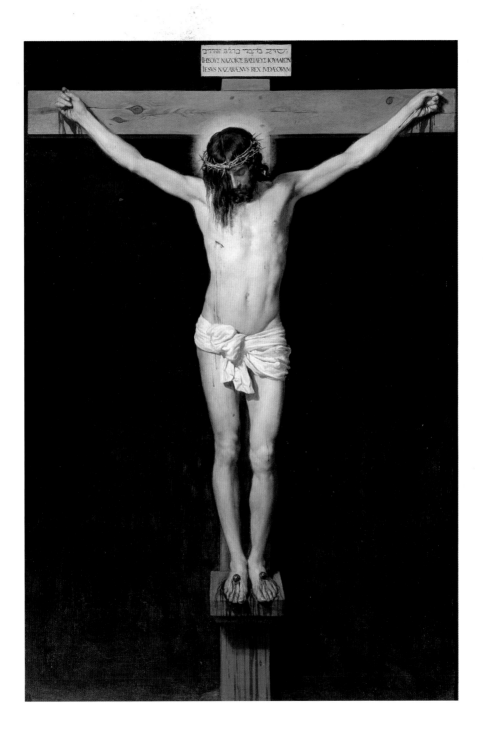

Philip IV of Spain in Brown and Silver

ca. 1631–32

Oil on canvas, 195 x 110 cm
The National Gallery, London

This official portrait was most probably executed during the period immediately following Velázquez's first study trip to Italy, and shows the king in an entirely different light. He has been portrayed standing full length, as was usual, but wearing an extremely fancy outfit, unusual for the austere dictates of male Spanish fashion at the time. He is wearing trousers and matching jerkin, which shows off his sumptuously embroidered shirt. The suit is made of expensive fabric, picked out with silver brocade, and is rounded off with a mantle and an elegant plumed hat, which is sitting on the table—the only piece of furniture in the room that acts as a backdrop to the portrait. As demanded by official portraiture, the king is grasping a folded piece of paper in his right hand, which bears one of the painter's signa-tures, while his left hand rests on the hilt of his sword. He is wearing the gold Bourbon fleece around his neck.

The crafting of this painting, and of the fabrics used to make up such an original costume, would have called for a detailed study of technique and an informed use of color. The sketchy brushstrokes are completely innovative for the period, employed in a bid to render the effects even more luminescent. This is possibly the first instance of Velázquez's new, post-Italy technique, which enabled him to achieve special lighting effects and served to set him apart from all the other artists of the period.

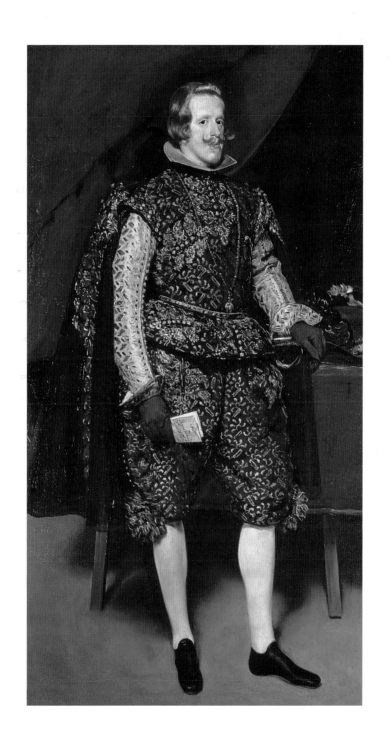

Don Baltasar Carlos with a Dwarf

1632

Oil on canvas, 128 x 101.9 cm
Museum of Fine Arts, Boston

Thought to be the first work Velázquez painted on his return from Italy, this canvas is
also the first portrait of Prince Baltasar Carlos, heir to the throne and son of Philip IV and
Isabella of Bourbon, but was only correctly attributed by Waagen in 1854, prior to which
it was believed to be a portrait of the Prince of Parma with a dwarf, by Correggio. This court
portrait was executed when the young prince was sixteen months old, according to the in-
scription "A E T A T. S A N N[...] / M E N S 4," in the most regal pose possible.
His hands are clutching the symbols of his regal status: the swagger stick in his right hand
and the sword in his left, of which only the elaborate hilt can be seen, the blade completely
hidden under the knot of his broad red sash that falls onto his splendid gold-embroidered
costume, and partly also covers his steel breastplate. His regalia is rounded off by a plumed
hat sitting on a nearby cushion. The depiction of the dwarf (a female figure, rather than a
male, as previously accepted by art historians) is freer in both style and pose and is much
more childlike than the official bearing of the young prince. She is holding a rattle and an
apple (a symbol of sensuality, but also of a lack of sense of duty), and wears a ribbon deco-
rated with shells in place of a sash.
A horizontal line breaks up the two planes of the composition, suggesting perhaps that the
painting may have been made at two different times, or, equally, marking the divide between
the prince on an upper level and the dwarf on a lower one. The composition is also reminis-
cent of a "picture within a picture," as though the dwarf were in front of a painting rather
than actually in the presence of the prince.

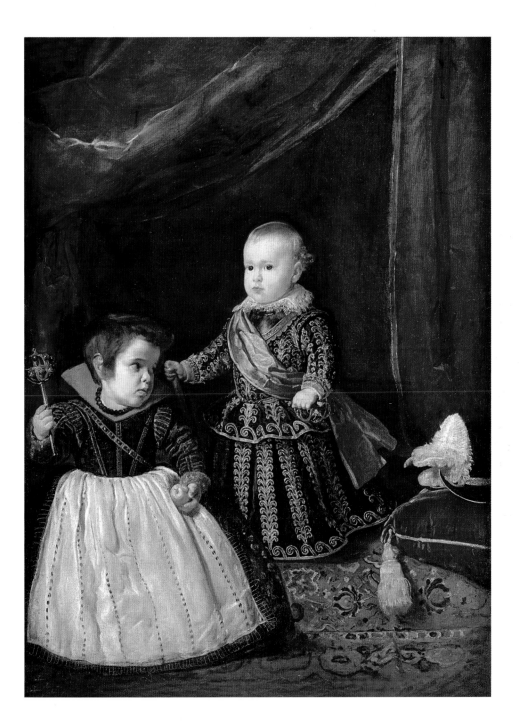

Christ after the Flagellation Contemplated by the Christian Soul

1628–29

Oil on canvas, 165.1 x 206.4 cm
The National Gallery, London

This painting was originally thought to have been inspired by the meditations of Saint
Bridget of Sweden, and her vision of the suffering endured by Christ during the Flagellation.
Subsequently, however, that interpretation was discarded after the realization that
Velázquez must have been acquainted with various passages from Saint Ignatius of Loyola,
consistent with the mysticism of the time. Thus the work is intended to represent the Chris-
tian soul, in the shape of a young girl, kneeling in contemplation before a scene from the
Passion. The presence of a guardian angel appearing to be indicating Christ as an example
to the Christian soul would appear to confirm that the painting contains a message, in line
with the mystical teachings of the time. This is thought to be the only painting by Velázquez
with any obvious link to contemporary mysticism. The spiritual contact between the young
girl representing the soul and Christ tied to the column is conveyed by a fine ray of light that
travels from the child's heart to Christ's head, at eye level. The figure of the angel corre-
sponds exactly to that of the archetypal guardian angel, who gently accompanies, watches
over, and advises. The compositional balance is rendered by the figure of Christ at the
center of the painting, the column on the left that balances out the figure of the standing
angel, and, lastly, by the diagonal line from bottom right to top left, which underscores the
mystical tension between the Christian soul and the suffering Christ.

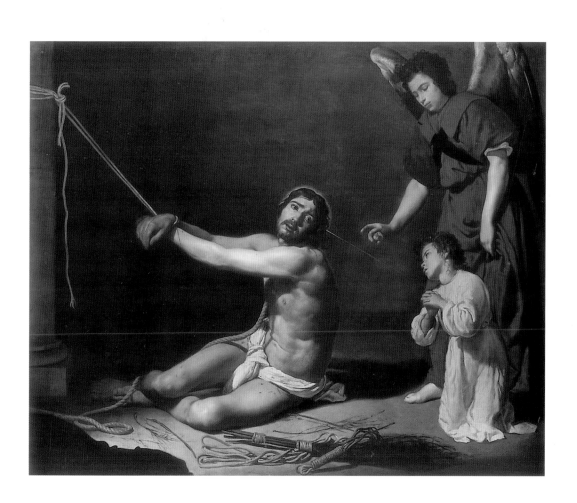

The Surrender of Breda, or The Lances

1635

Oil on canvas, 307 x 367 cm
Museo Nacional del Prado, Madrid

The handing over of the keys after the fall of the city of Breda took place in 1625 and was immortalized by Velázquez for the Buen Retiro in around 1635. It is a masterpiece of historical genre painting and also the largest surviving work by Velázquez.

Some ten years after the Spanish army took Breda (June 2, 1625), the painting was made to celebrate the monarchy and its amazing triumph during the early reign of Philip IV. Ambrogio Spinola is seen receiving the keys of the city from Justin of Nassau. A certain magnanimity is discernible in the gesture of Count Spinola, in the center of the composition—in which, unusually, both figures are shown standing—who appears inclined to bid his defeated adversary to rise from his bow. All the characters are extremely well crafted, and Count Spinola's face in particular is good enough for a stand-alone portrait, especially as the artist had actually met him personally on his first journey to Italy, from Barcelona to Genoa. The lances make up a virtual portcullis in front of the landscape, creating a trompe-l'oeil effect, those of the Spanish soldiers, compact and vertical, contrasting with the few slanting Dutch ones on the other side, as if to demonstrate the strength and discipline of the victors, as compared with the lowered, disorderly Dutch ones. The defeated army is depicted in subdued tones, traipsing through the immediate background, in front of the battlefield and fallen city, which make up a marvelous Dutch landscape, which Velázquez would never have actually seen for himself, but would have drawn from a study of Flemish engravings and paintings.

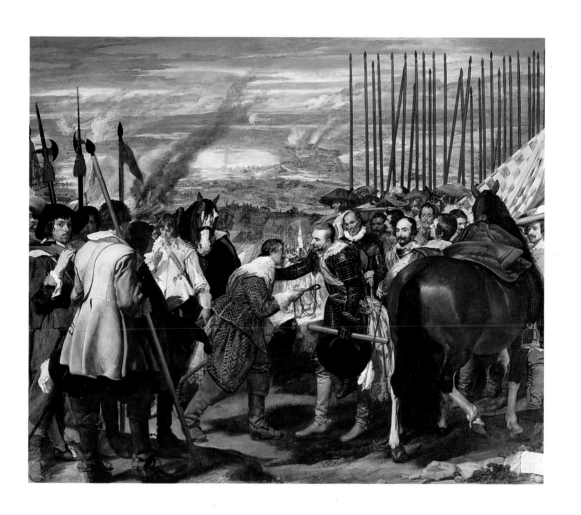

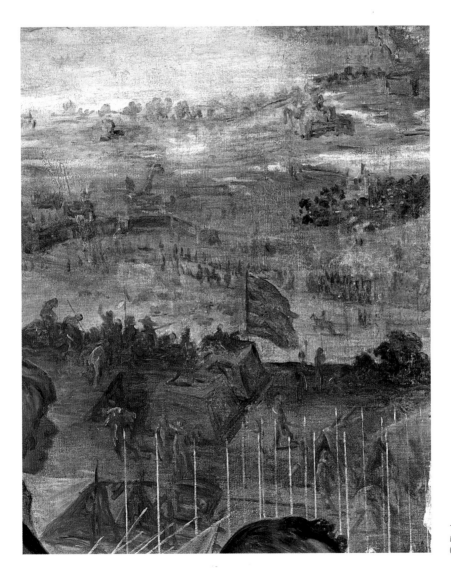

The Surrender of
Breda, or The Lances
(details)

Saint Anthony the Abbot and Saint Paul, the First Hermit

ca. 1634

Oil on canvas, 257 x 188 cm
Museo Nacional del Prado, Madrid

The painting was likely to have been made for the Convento de San Pablo, near the Buen Retiro, and later moved to the small church of San Antonio. For some time the date of its creation remained somewhat hazy, varying somewhere between 1640 and 1660; some experts even believed it to have been Velázquez's last ever painting. The subject was inspired by different episodes in the hagiography of Saint Anthony the Hermit and Saint Paul, and drawn from the Golden Legend, most probably drawn from the iconography Velázquez would have studied and picked up during his travels in Italy. There are clear references to a Dürer woodcut, to a fresco by Pinturicchio in the Borgia apartments at the Vatican, the Savoldo in the Accademia in Venice, and to Patinir (now in the Prado), all dealing with the same subject.

Velázquez has placed the main event, the meeting between the two hermits, in the foreground, with the raven flying down to give them equal portions of bread. Behind them, the depiction takes a more circular approach, becoming more complicated with the incorporation of other events linked to the meeting and friendship of the two hermit saints. There is a depiction in the far background of Saint Anthony meeting the centaur and of the satyr showing them the way to the Convento de San Pablo; we see Saint Anthony knocking on the grotto door, and Saint Anthony again, praying over the body of Saint Paul while two lions prowl about digging for the latter's grave. The landscape is clearly the protagonist of this painting, which has been fluidly and lightly crafted, in the manner of the painters of Flemish landscapes.

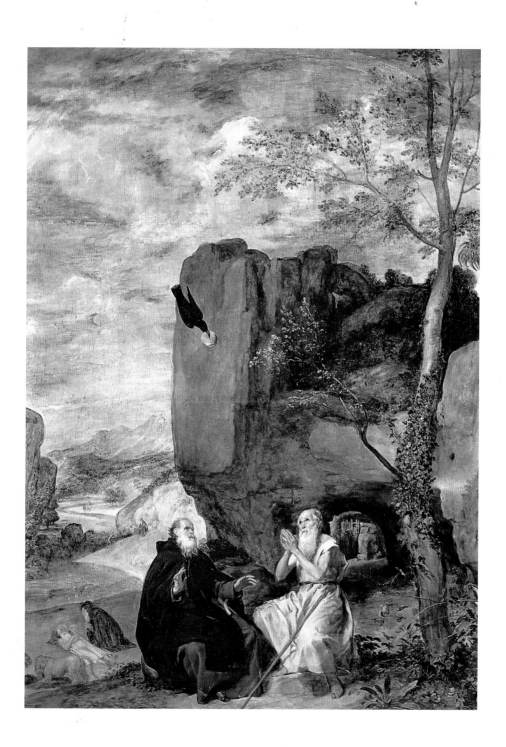

Felipe IV on Horseback

1631–36

Oil on canvas, 303 x 317 cm
Museo Nacional del Prado, Madrid

Quite possibly the most splendid work in the Great Hall of the palace of Buen Retiro, this equestrian painting was executed at some point between 1631 and 1636. The painting would certainly have required a lengthy period of study and careful observation of horsemanship, which is what made it so perfect. The rendering of the king's almost imperceptible movement, his hand clasped firmly round his staff, his spur just nudging his horse encouraging it to perform a curvet, a position that can only be kept up for a few seconds, extremely realistically crafted by the artist. Technically, the elegant bearing of both horse and rider, which could only have been achieved by a consummate horseman like Philip IV (trained at the Vienna School), relies entirely on the sureness of the animal's hind legs. Over time, a pentimento has come to light, showing that Velázquez made a slight alteration to the profile of the horse, moving the leather back slightly in order to change the outline of the muzzle, which shows no signs of having been retouched. The bay horse, with its white muzzle and hooves and black mane and tail, is shown in stark profile in line with the volume of the body, befitting the stern severity of the painting as a whole; the effort required by the pose is also underscored by the horse's flared nostrils and drops of saliva. Velázquez has painted a landscape behind the statuesque portrayal of the king, seen from above, rather as if mount and rider were on a hillock. The line of hills and vegetation are reminiscent of the Pardo area, and the feeling of distance is achieved in masterly fashion with an unparalleled use of blue and silvery tones.

Felipe IV on Horseback
(details)

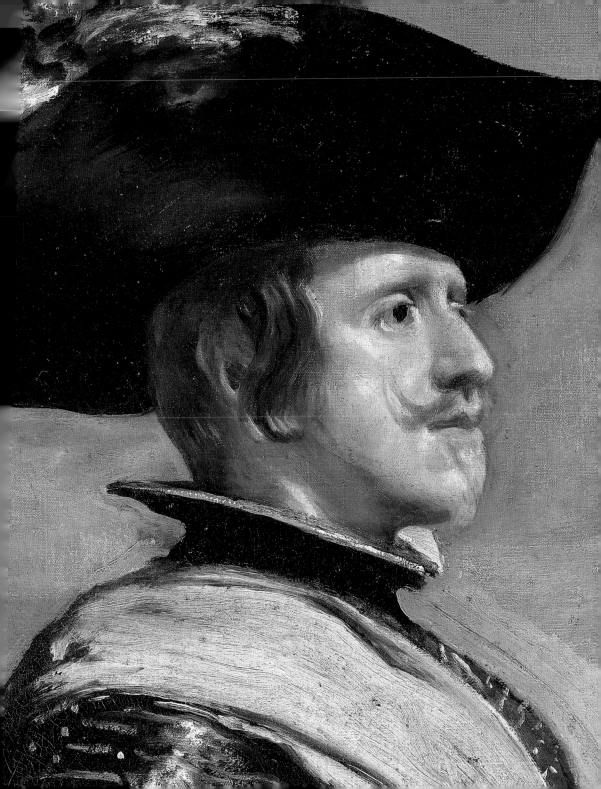

Prince Baltasar Carlos as a Hunter

1635-36

Oil on canvas, 191 x 103 cm
Museo Nacional del Prado, Madrid

Velázquez painted several portraits of members of the royal family dressed as hunters and accompanied by their favorite animals, set against tranquil wooded and mountainous landscapes, for the Torre de la Parada hunting lodge near El Pardo. His results were surprising: the introspective intent is perfectly pulled off in each individual figure, especially as he was able to dispense with etiquette and render these particular paintings with greater sensitivity and simplicity. It also gave him another opportunity to test his prowess at landscape and to try his hand at animals, at which he proved to be extremely skilled. The royals are not surrounded by the trappings and symbols of pomp and splendor, but by the Sierra de Guadarrama, with its oak woods and snowy mountain peaks. Of all the portraits, this one of Prince Baltasar Carlos is probably the very best ever painted of the young prince, capturing the fresh innocence of childhood. The prince is striking a very adult pose with his harquebus (possibly the one given to his father by the Viceroy of Navarra), and has been painted with his favorite animals, a Spanish pointer and a greyhound. The head and front legs are all that can be seen of the latter (the canvas has been cut). The painting was executed between 1635 and 1636, according to a note stating that the prince, born in December 1629, was six years old.

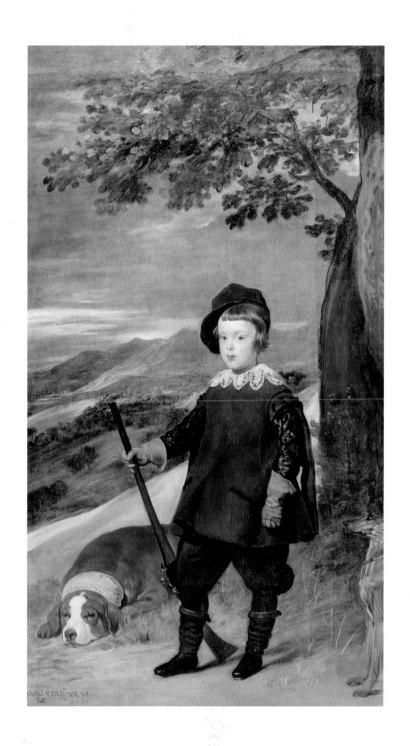

Prince Baltasar Carlos on Horseback

1635–36

Oil on canvas, 211.5 x 177 cm
Museo Nacional del Prado, Madrid

Prince Baltasar Carlos also had the honor of having his equestrian portrait included in the scheme for the decoration of the Hall of Realms at Buen Retiro, along with those of his grandparents and parents. It was intended to mark his guarantee of succession, but this was not to be. Already ill at the time the painting was made, he died shortly thereafter. This equestrian portrait, set against the Pardo landscape, has taken a particular bottom-up approach, suggesting that it may have been intended to hang above a door. This postulation could also be justified by the frequently noted and much criticized massive belly of his mount which, seen frontally, looks hugely out of proportion to the rest of its handsome body. The prince, who is wearing a melancholic expression, would have been aged about five, and is shown galloping in the Sierra de Guadarrama, recognizable by the distant snowy peaks of the Maliciosa. The finely graduated colors train the eye from the snow-capped mountains and cloudy sky down to the foreground and the delicate pink sash tied across the prince, which flows out behind him as he gallops on. Velázquez has used swift, fluid brushstrokes to render the bright colors of the prince's costume, which echo the tones of the natural landscape, and to bring movement and clarity to the scene.

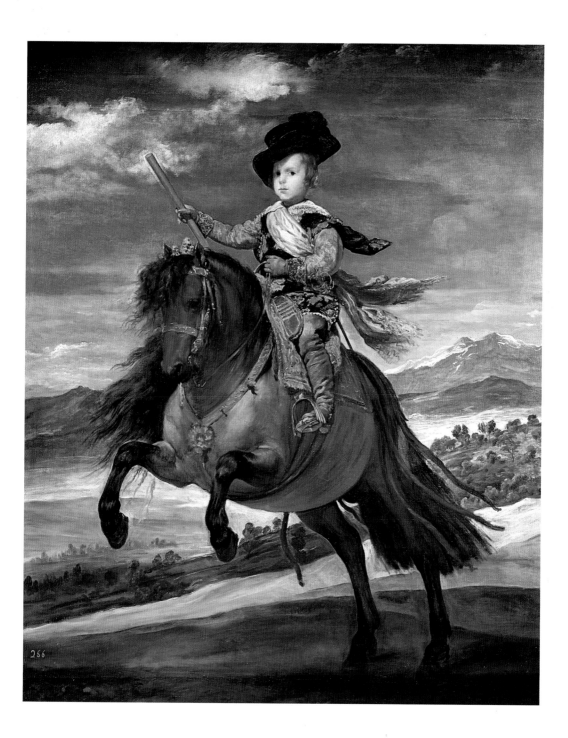

266

Portrait of Francesco I d'Este

1638–39

Oil on canvas, 72 x 55 cm
Galleria Estense, Modena

Francesco d'Este, Duke of Modena, commissioned the portrait himself from Philip IV's court painter, most probably during his visit to Madrid between 1638 and 1639. The documentation, contained in a letter sent by one of his diplomats to Madrid, confirms that Velázquez was working on the portrait in March 1639. Other ancient sources also prove that at least one other work must have been commissioned by and executed for the Duke of Modena (an equestrian portrait that has vanished without trace), underscoring the esteem in which Velázquez was held.

Several years after Velázquez had completed and delivered the painting, he had occasion to see it again (in the late 1640s), when it was conserved in the duke's collections at the court of Modena, although it was not inventoried until 1663. The lower half of the painting has been damaged, and it has been executed in an unusual manner, with precise, fine brushstrokes for the face, whereas the head and shoulders have been rendered more freely and fluidly. Francesco d'Este's bust is shown in profile, his head turned three quarters to look out of the painting. His noble status is referenced by his insignia, which underscore his strong political links to the Spanish crown: the gleaming armor across which the red sash of the General of the Seas is tied, a title bestowed on him by Philip IV in 1638, along with the gold fleece, signifying his knighthood and his title of Viceroy of Catalonia.

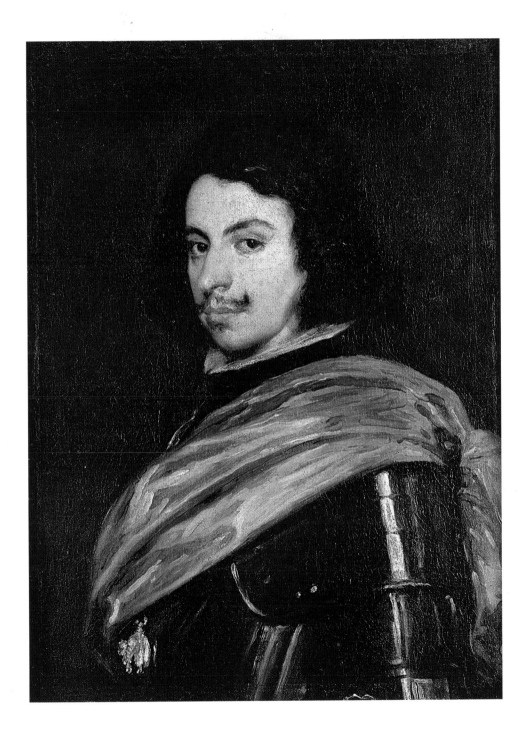

Mars

ca. 1641

Oil on canvas, 179 x 95 cm
Museo Nacional del Prado, Madrid

Mars was one of Velázquez's paintings of mythological characters and figures from an-
tiquity. The king had commissioned Rubens to decorate twenty-five rooms in his hunting
lodge on a mythological theme. Spanish artists devoted considerably less time to mytho-
logical subjects than their colleagues elsewhere in Europe. There is a close tie between the
culture of the Spanish painters and the literature of the Golden Age, which was character-
ized by writers such as Góngora, Lope de Vega, and Cervantes, who took their own particu-
lar satirical spin on mythology and tended to portray the divinities as uncouth men and
women. It is also likely that, under the Counter-Reformation, Spanish artists and writers
used satire to signal their non-involvement with paganism, treating mythology as mere
entertainment. Velázquez's mythological works show that he subscribed to this trend,
despoiling his mythological subjects of their heroic grandeur. Thus Mars looks more like a
thoughtful cuckolded husband, with the symbols of his power discarded in the foreground,
than a proud god of war. Although Velázquez's approach is entirely different to that of the
Italian Mannerists, he has nonetheless drawn on his studies of ancient art—Mars's pose is
largely derived from a close study of the *Ludovisi Ares*, although, in this case, the subject is
deep in thoughts of a wholly human nature.

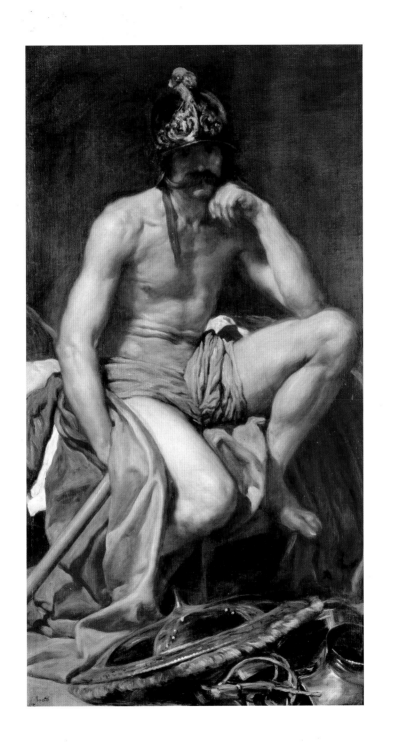

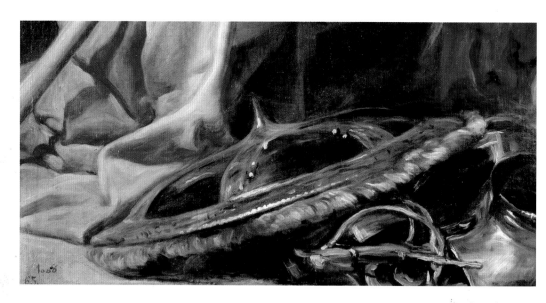

Mars (details)

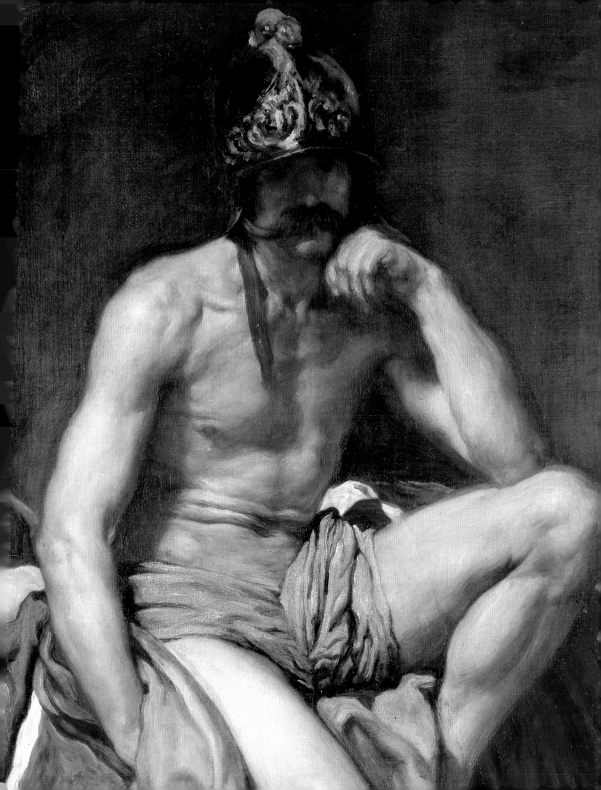

Menippus

1639–40

Oil on canvas, 174 x 94 cm
Museo Nacional del Prado, Madrid

This tall, narrow canvas was painted for the Torre de la Parada, along with its companion piece *Aesop* (now in the Prado), and was probably destined to hang between two of the windows. Menippus was a third-century-BC Greek philosopher and Cynic, here represented as a contemporary of the painter, in modern clothes and swathed in a long cape, a hat that could derive from a picaresque novel, and long boots. The illusion of depth in a room that could be described as neutral and lacking any particular connotations is helped by the position of the philosopher, a tall man not seen in a frontal pose, but depicted in line with various painted objects on the floor which serve to emphasize the perspective: an open book and, on the right, slightly further back, a shelf of some kind holding an amphora. The play of light rounds off the composition as it shifts away from the foreground, while the use of a palette of colors entirely based on shades of brown, as well as the use of white, is a supreme example of Velázquez's ability to synthesize. A few essential elements such as his face, which seems just to have whipped round, wearing a rather perspicacious expression, the position of his left hand holding onto his cape at chest level, and the simple collection of items at his feet serve to remind us that this is a figure from antiquity. The amphora on the shelf resting on two stones could be an allusion to a philosophical allegory on the uncertainty of life.

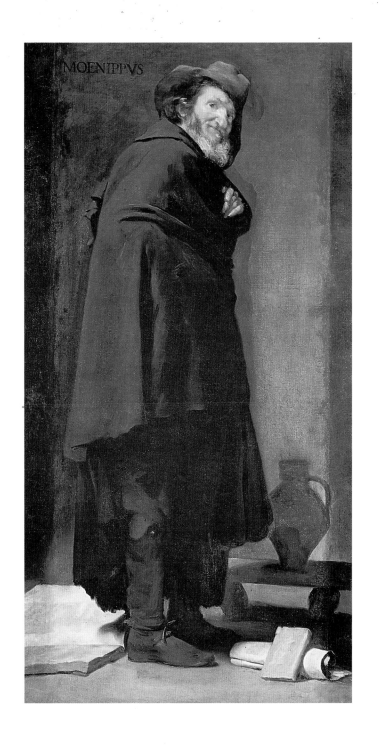

The Needlewoman

ca. 1640–50

Oil on canvas, 74 x 60 cm
National Gallery of Art, Washington, D.C., Andrew W. Mellon Collection

By the mid-1650s, Diego Velázquez was firmly established as a court painter to Philip IV, having largely been engaged in producing official portraits of the royal family and its entourage since 1632. His duties did not prevent him from making portraits of other, less magisterial subjects, for the purposes of study or personal pleasure, however, and these enabled him to free himself from the narrow conventions of official portraiture.

The model for *The Needlewoman* has been tentatively identified by some critics as his daughter Francisca, although the unfinished work was still in his studio at the time of his death and was inventoried conventionally as "Head of a Woman Sewing." The domestic theme could have been inspired by contemporary Dutch paintings, which often portrayed women busy with their embroidery, making lace, or sewing; it seems unlikely that Velázquez set out to celebrate feminine virtues, rather that he was attempting to put the finishing touches on a technique that consisted of flaking and liquefying the colors. The fact that the work has remained unfinished permits Velázquez's technique to be examined. He has seasoned the canvas with a base of earth-colored tones, which still show through the paint on the cushion, and then defined the outlines with swift black brushstrokes before finishing off each element. He has harnessed the light brilliantly from top right, as it rests on the head of the girl bent over her work, glancing off her hair and onto part of her face, before pooling on her décolleté and the needlework, which look marvelously realistic.

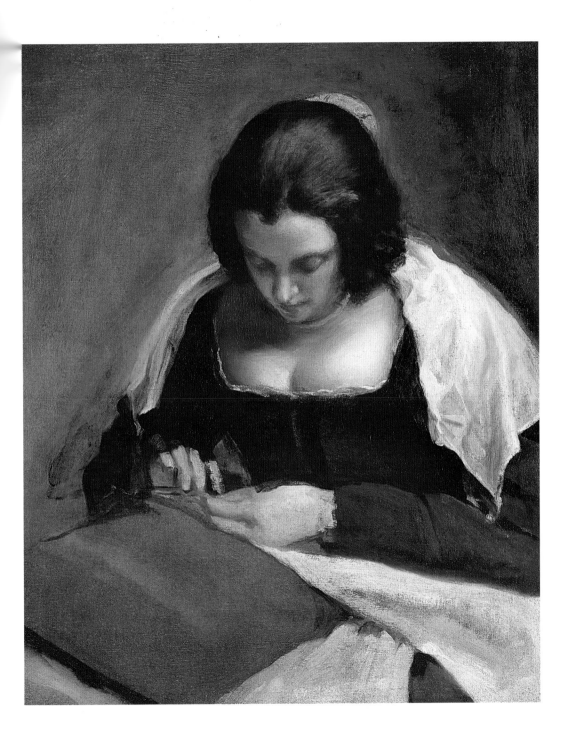

The Coronation of the Virgin

ca. 1635

Oil on canvas, 176 x 124 cm
Museo Nacional del Prado, Madrid

This was painted for Queen Isabella of Bourbon's oratory at the Alcázar in Madrid. It belongs to Velázquez's second cycle of religious works, executed after he had been at the royal palace for some time and thus in a position to intersperse his court paintings with works of piety and devotion. It was still a work commissioned by the king, with classical echoes that almost certainly derive from Italian painters, in terms of both approach and palette. The painting shows the Virgin being crowned in heaven by the three members of the Holy Trinity, and is on an upturned triangular plan, conferring an effect of harmony and grace, emphasized by the skilled use of deep reds and blues—colors that do not necessarily sit well together—and intensity of color emphasized by the all-pervading light of Paradise that manages to remain fairly natural. Velázquez has taken a decisive approach to the theme of Marian devotion, which certainly derives from the tradition of Christian iconography, at a time when Catholic Spain, in line with the dictates of the Council of Trent, was fighting the Protestant doctrine, which rejected the worship of the Virgin Mary. Although created while in the service of the king, Velázquez managed to imbue the painting with great piety, with no concessions to fanaticism or ostentation.

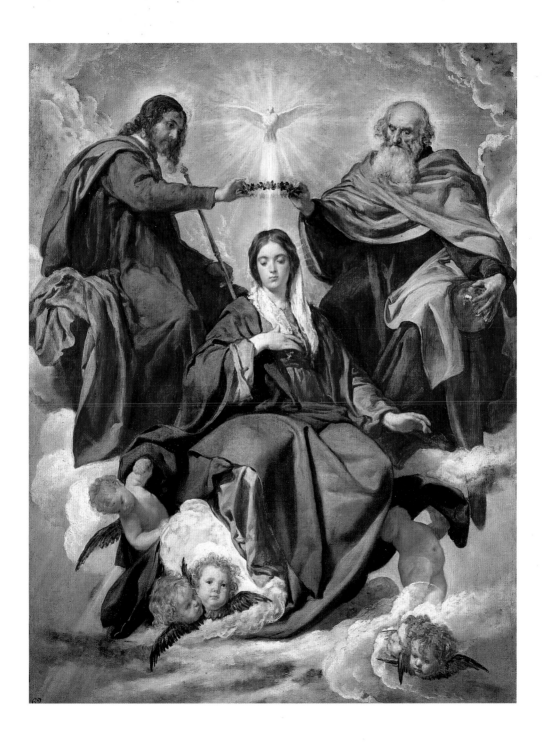

*The Coronation of the
Virgin (details)*

Self-Portrait

ca. 1643

Oil on canvas, 103.5 x 82.5 cm
Galleria degli Uffizi, Florence

Self-portraits were not a particularly popular genre among the Spanish painters of the Golden Age, which makes tracking down an authentic portrait of Velázquez no easy matter. Several of his surviving works are traditionally said to contain self-portraits. These are early portraits, and inclusions of his own face in figures of other subjects (such as one of the Magi in the *Adoration of the Magi* in the Prado and *Saint John the Evangelist on the Island of Patmos* in the National Gallery in London), chiming with his habit of using models from his own immediate circle and his desire to use his own face as practice material. The self-portrait now in the Uffizi was brought to Italy by one of Grand-Duke Cosimo III's envoys in the late seventeenth century, and is clearly one of the works executed shortly before the painter's second trip to Italy, in terms of both approach and style. Compared with previous portraits, excluding those of people in court circles or high prelates shown full length, this marks a change in composition, merely depicting the head and shoulders or half busts, seen three quarters on. Velázquez's sparing use of color, as was the convention in the court of Philip IV, clearly derives from a particular interest in Titian; the color is applied more swiftly and less densely. It is fascinating to see just how Velázquez has portrayed himself as a leading member of the court, judging by his pose, his hand on his hip to indicate self-confidence, his clothing, his gloved hand, the hat in his left hand, and the keys that signal his recent elevation to the position of gentleman of the bedchamber. Above all, however, it is the penetrating gaze that so powerfully transmits the magnitude of this painter.

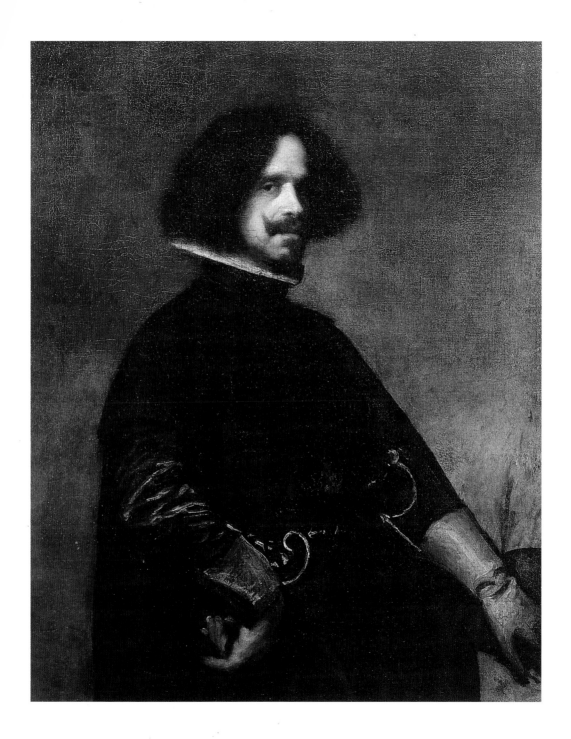

The Buffoon Sebastian de Morra

ca. 1646

Oil on canvas, 106.5 x 82.5 cm
Museo Nacional del Prado, Madrid

The dwarf and jester Don Sebastian de Morra joined the court in 1643 (from Flanders,
where he had been employed by Cardinal-Infante Ferdinand), and entered the service of the
young Prince Infante Baltasar Carlos, after whose death in 1646 he remained at court,
where he died in 1649. The fact that he was part of the infante's retinue meant that he was
accorded certain privileges normally unavailable to men of lowly stature—dwarves, jesters,
and simpletons, whose defects and deformities helped to accentuate the beauty and wealth
of those more fortunate than themselves. Velázquez made some extremely accomplished
portraits of these providers of entertainment and amusement, not highlighting their de-
formities but endeavoring to capture the very essence of their souls through glances, ex-
pressions, and postures. This approach holds good in this portrait of the dwarf Sebastian
de Morra. His privileged position is signaled by his clothing and the elegant Flanders lace
collar and cuffs, and he is set against a neutral background that serves to draw the ob-
server's eye towards his facial expression. The painting has been made with broad brush-
strokes, bright tones, and a far more sumptuous range of colors than was usual in portraits
of court jesters.

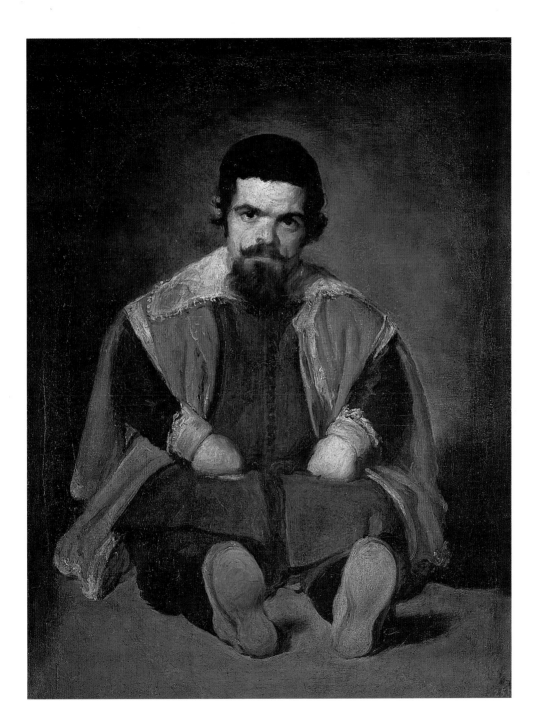

The Medici Gardens in Rome (Pavilion of Ariadne)

ca. 1630

Oil on canvas, 44 x 38 cm
Museo Nacional del Prado, Madrid

The chronology of this companion piece to *The Medici Gardens in Rome* (Façade of the
Grotto-Loggia), also in the Prado, is still uncertain. While the subject matter and the
Prado's dating of the work states it was made during Velázquez's first visit to the Villa
Medici in Rome, the fluid, disjointed, almost sketch-like technique would rather suggest a
later date, during Velázquez's final years, which would mean it could also have been ex-
ecuted during his second trip to Italy. What is so extraordinary about this painting is the fact
that this was the first time an almost portrait-like approach had been taken to a landscape
subject by any Spanish painter, which indicates that it was very probably painted from
nature. The unusually modern compositional quality and technique of several passages in
both views of the Medici Gardens prefigure Corot and the pre-Impressionist painters. The
statue of Ariadne in the middle of the pavilion has been depicted by the light of the after-
noon sun. The figures outside the pavilion have never been identified, but serve as mere
adjuncts to this finely crafted and beautiful landscape work.
Velázquez's overall vision has culminated in an extremely handsome painting that conveys
the freshness of a corner of the garden at the Villa Medici, to which he had moved precisely
in order to escape the suffocating summer heat of Rome.

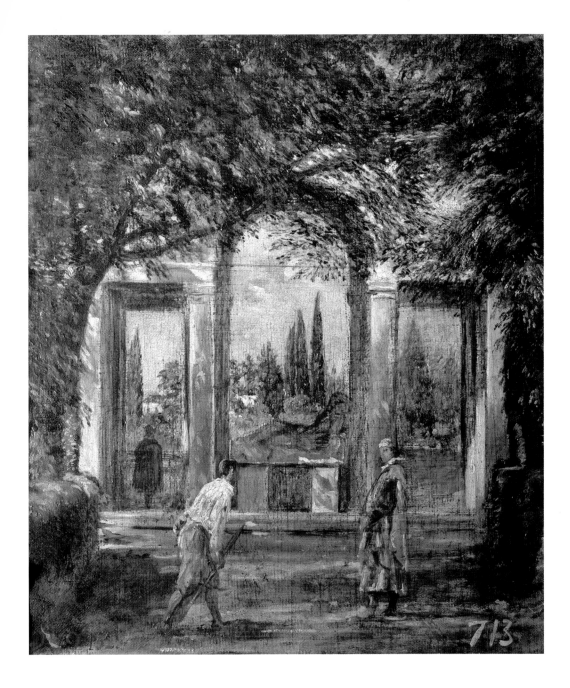

Juan de Pareja

1650

Oil on canvas, 81.3 x 69.9 cm
The Metropolitan Museum of Art, New York

Juan de Pareja was the mulatto who had accompanied Velázquez on his second trip to Rome to acquire works of art for the Alcázar on behalf of the king. This portrait may have been a preparatory exercise for his portrait of Pope Innocent X and was completed in early 1650. It made its first appearance on Saint Joseph's Day, March 19, at the exhibition organized by the Confraternity of the Virtuosi at the Pantheon, to which Velázquez had been admitted the previous month. It was an immediate and huge success, and of all the paintings shown at the Pantheon, this was the only one of all the portraits described as "truth" rather than art. The most striking thing about this picture is the quasi-sneering yet noble face of the servant—who was shortly to extricate himself from service, with the king's help, and regain his freedom. His gaze is so penetrating and proud that it chimes perfectly with his elegant pose and handsome attire. Of the few details, the fine, broad Flanders lace collar is worthy of note, because it was an item of clothing not just forbidden to slaves but even eschewed by the king in favor of more somber clothing. Another important detail is the darker sash that crosses over the fastening of the jacket. It is like a bandolier that underscores the slave's slightly challenging, almost military manner. The restricted palette is reminiscent of the painter's early work. Juan de Pareja's body mass stands out against a grayish green background, rendered in a huge range of browns tending almost to black. The faint pale marks on the velvet cuff serve to highlight the splendor of the fabric.

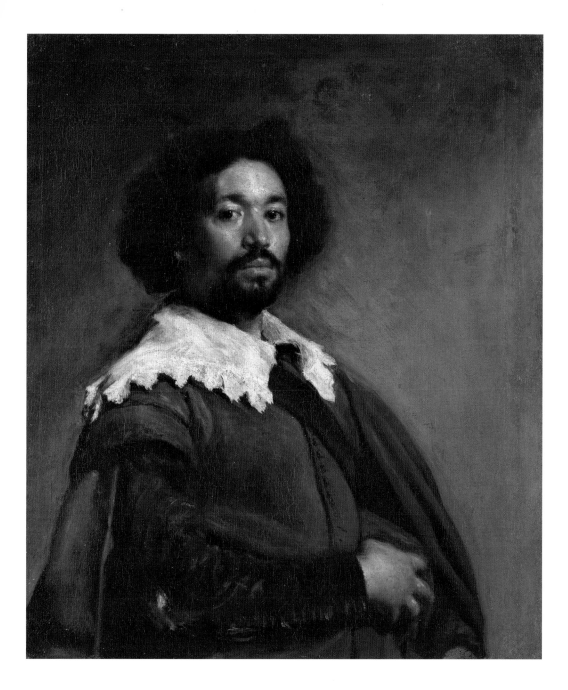

Pope Innocent X

1650

Oil on canvas, 140 x 120 cm
Galleria Doria Pamphilj, Rome

This extremely famous portrait of the pro-Spanish Pope Innocent X was executed in 1650. The circumstances surrounding its commissioning are unknown, but Velázquez refused to take any remuneration, instead accepting a chain with a papal medallion in lieu of payment. It has been postulated that Velázquez might have been acting as envoy for Prince Camillo Pamphilj (to whom the painting is known to have belonged in 1652), but a more likely hypothesis is that the painter and the pope were actually directly acquainted, perhaps having met in 1626–29, when the then future pope had accompanied the pope's legate, Francesco Barberini, to the court of Madrid. It has also been suggested that the portrait might have been intended as a gift to Philip IV. According to his biographer, Palomino, Velázquez is traditionally held to have drawn on El Greco's portrait of Cardinal Niño de Guevara (Metropolitan Museum of Art, New York), executed between 1596 and 1601. However there are also clear references to celebratory portraits by other great Italian painters, such as Raphael's *Portrait of Pope Julius II* (1511, National Gallery, London) and Titian's *Portrait of Pope Paul III* (1543, Museo Nazionale di Capodimonte, Naples).

This was an extraordinarily realistic rendition of the pope, who is said to have been so delighted by it that he exclaimed "All too true!" Even his face carries echoes of the masterful application of different reds used to render his throne, his silk hat, his amice, and particularly his lips, which are set extremely severely. The pope is holding a folded sheet of paper in his left hand; this is in fact a credential bearing one of Velázquez's rare signatures because, although in Spain this could not have been attributed to any other hand, he knew that there were artists in Italy capable of painting like him.

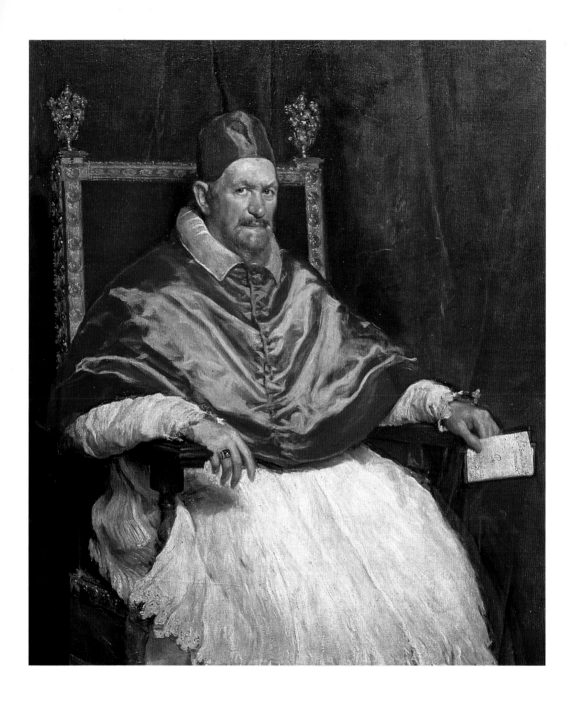

The Toilet of Venus ("The Rokeby Venus")

1647–51

Oil on canvas, 122.5 x 177 cm
The National Gallery, London

This clearly owes its inspiration to mythology and various earlier masters (such as Titian and Veronese) and is the only surviving nude by Velázquez, although there is documentary evidence of other such works by his hand. He may have been inspired by the classical sculpture he would have seen in Rome (the Borghese *Hermaphroditus*, now in the Louvre; the statue of Ariadne previously in the Villa Medici and now in Palazzo Pitti in Florence) and there are certain parallels with Michelangelo's frescoes in the Sistine Chapel, which would put this work among those executed while in Rome during his second trip to Italy. The painting was inventoried in 1651 among the possessions of the Spaniard Gaspar Méndez de Haro y Guzmán, Marquis of Carpio and de Felice, a relative of the Count-Duke of Olivares, and thirty years later, while remaining in the same hands, it moved to Rome and then Naples. The extraordinarily consummate rendering of the back view of the nude is confirmation of Velázquez's careful study of sixteenth-century and classical Italian art, and of his amazing gift for bringing his subjects to life. In this case sensuality and voluptuousness are encapsulated by the presence of Cupid, in a mythological twist. He is holding up the mirror for Venus, its unused ribbons around his wrists and his hands crossed, symbolic of the powerful link between Love and the image of Beauty, a voluntary captive of his fatal power. Venus's face, which may be that of his lover Flaminia Triva, is reflected in a polished steel mirror, in a play of light more typical of the Dutch masters. The confused image in the background of the mirror is a symbol of visual perception, nothing more than a series of reflections.

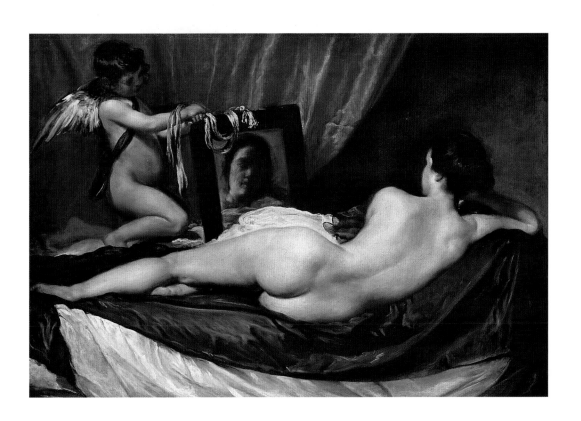

Mariana of Austria

ca. 1652

Oil on canvas, 234.2 x 132 cm
Museo Nacional del Prado, Madrid

Mariana of Austria, the niece of her mother Maria's brother Philip IV, had been promised
to Baltasar Carlos, but things changed after his untimely death, and in 1639, aged only four-
teen, she was married to her much older uncle. This was the first portrait Velázquez man-
aged to paint of the young queen, having been in Italy during her first few years at court; it is
also the only full-length painting of Mariana, and it sticks rigorously to the canons of official
portraiture.

Her regal figure is framed by the ample, soft fabric of the drape (a later twenty-centimeter
addition has been made at the top of the painting). Her splendid attire is almost over the
top, suggesting that Velázquez allowed himself a touch of theatricality in the extraordinarily
wide skirt, lace, and complicated hairdo. She is posing with one hand resting on the chair,
denoting her rank, which is underscored by the clock on the red tablecloth, a symbol of both
temperance and the transitoriness of life (as an element of vanitas). As in most full-length
portraits of the time, there is a powerful contrast between the outstanding technical skill
evident in the brushstrokes used to define many of the details and the rigid bearing and
impassive expression of the queen forced to pose for the painting.

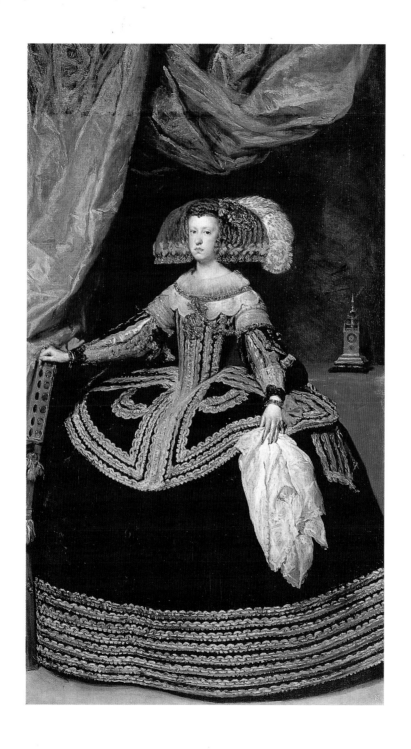

Infanta Margarita Teresa in a Pink Dress

ca. 1653–54

Oil on canvas, 128.5 x 100 cm
Kunsthistorisches Museum, Vienna

The Infanta Margarita Teresa, daughter of Philip IV and Mariana of Austria, was the member of the Spanish royal family most frequently painted by Velázquez. Margarita had been promised to her cousin Leopold of Hapsburg, to whom portraits of his intended bride had been sent from Madrid at two-year intervals from infancy to girlhood, prior to their marriage in 1666. This is the first painting in a series executed by the court painter, when the princess would have been between two and three years old. Despite the rigorous formality of court portraiture, which dictated that subjects were always represented in a full-length, standing position, one hand resting on a table, as a traditional symbol of power, the formality and etiquette of the composition as a whole are leavened by two particular details. There is no clock on the table, for example, which is usually included as a symbol of power over time, and therefore a worthy attribute of any leading member of a ruling royal family. Instead there is a simple vase of flowers, notable for the purity of its transparent beauty, from which a flower has fallen, possibly symbolizing the delicate and fragile nature of infancy. There is also a large Oriental cushion on which the girl is standing to bring her up to table height, another detail that mitigates the official nature of the portrait and a device for accentuating the diagonal depth of the painting. The colors are stunning, serving to accentuate the pink and silver dress against the green curtain.

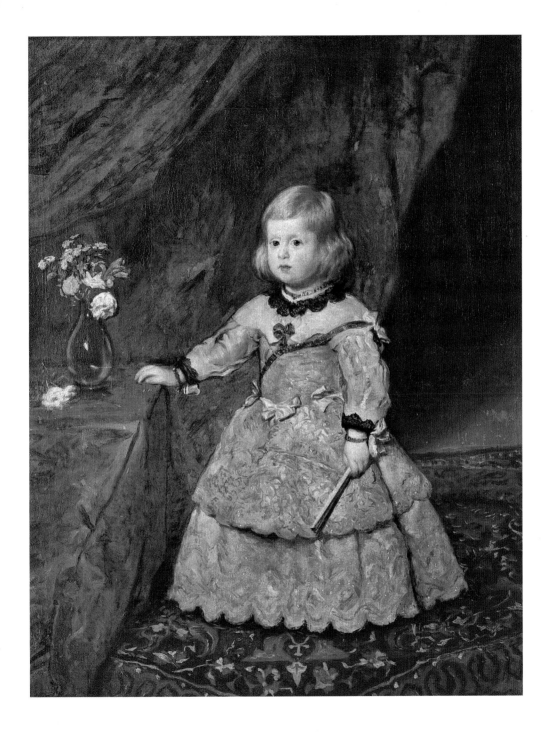

Felipe IV

ca. 1653

Oil on canvas, 69.3 x 56.5 cm
Museo Nacional del Prado, Madrid

This is one of the last portraits Velázquez ever painted for Philip IV, in around 1653. In 1653, the king wrote to him "you have not painted a portrait of me for nine years, but I do not feel inclined to subject myself to your phlegm and thus see myself aged." The king was clearly well aware that his own court painter would not have jeopardized the reality of his portraiture, at which he excelled, in order to conceal the extant, visible, and recognizable marks of time on his sovereign's face. Although the painting shows a decidedly older king than the early official portraits, Velázquez has also shown his huge respect for him in faithfully reproducing the true gaze of a man unable to hide his years, his weariness with life, his concern over his declining kingdom (following the failure of the Count-Duke of Olivares's political maneuverings), nor indeed his personal tragedies (the death of his first wife and that of his young son Baltasar Carlos). Velázquez has honed a technique that enables him to employ lighter, less laden brushstrokes without detracting from his highly skilled precision—in the rendering of the velvet jacket, for instance, and the starched collar onto which the king's fine curls fall, his hair worn longer than in the early portraits and yet another sign of the passage of time and changing fashions. He has captured the absorbed expression that betrays a particular state of mind; this aging king is clearly weighed down by his responsibilities, but has been depicted in the requisite detached pose and bearing for an official portrait.

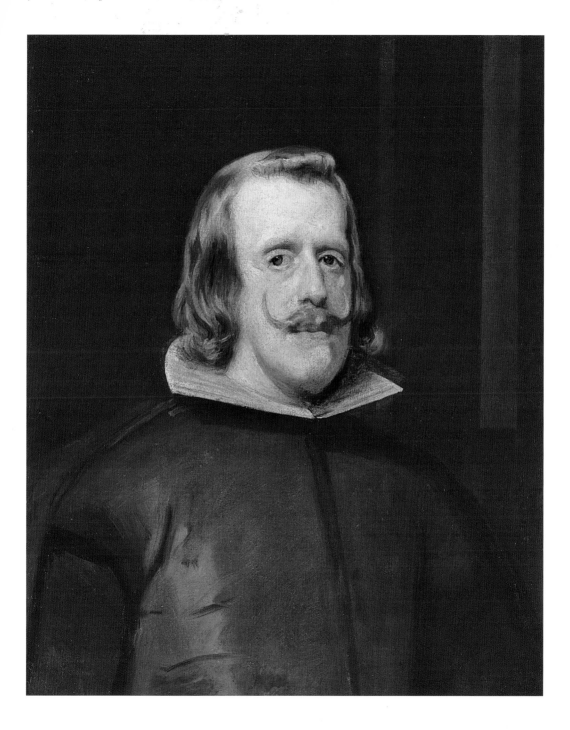

The Family of Felipe IV, or Las Meninas

ca. 1656

Oil on canvas, 318 x 276 cm
Museo Nacional del Prado, Madrid

This was one of Velázquez's most famous paintings for the royal family and has the air of a snapshot, with the painter himself as one of the subjects, a sign of his awareness of how high he had risen in the ranks. The Infanta Margarita Teresa sets the scene by erupting into the painter's studio, followed by her maids of honor and dwarves, as the royal couple are posing; she is not, however, the sole protagonist. Just who exactly Velázquez was setting out to paint, and whether or not the image reflected in the mirror (Philip IV and Mariana are only just identifiable inside a frame behind the painter, as interlocutors on the same level as him, through the happy medium of the painting within a painting) corresponds to a depiction already on the canvas or to other people present in his studio. If the king and queen, re-flected in the mirror, are not the sole protagonists, then perhaps they include the painter at work, not to mention the maids of honor and the dwarves, the Infanta Margarita (note the dewy quality of the depiction: the figure of the dwarf appears unfinished, rather blurred at such close quarters, out of the observer's line of sight), the female attendant to the queen's ladies-in-waiting and the major-domo, and, towards the back of the room, José Nieto Velázquez, head of the royal tapestry works and future palace marshal. The only immobile figure in the entire painting is the Infanta Margarita Teresa, who seems to be posing while looking at her parents and, indirectly, also the observer. Although he has placed himself slightly in the shade, the artist has managed to include his own self-portrait with the Cross of Saint James prominently emblazoned on his chest; he may have painted it himself or it may have been a later addition by the king himself, but it denotes his membership of the Order of Santiago, and is therefore a major testament to the recognition of his nobility.

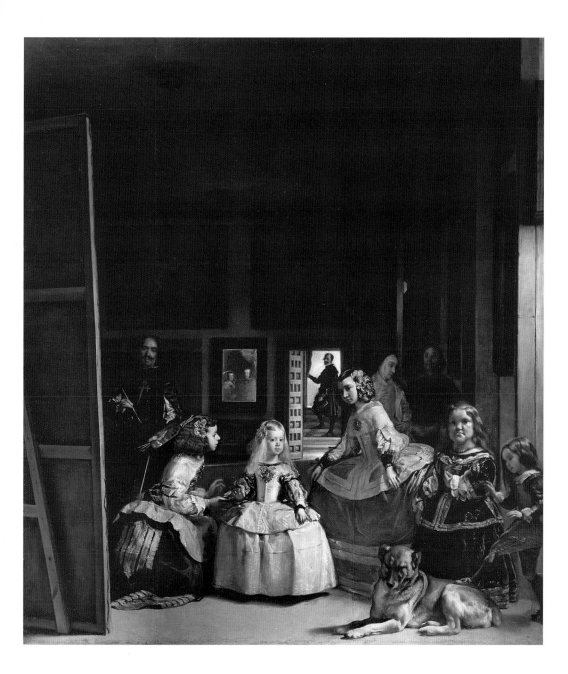

The Family of Felipe IV,
or Las Meninas
(details)

The Fable of Arachne, or Las Hilanderas

ca. 1657

Oil on canvas, 220 x 289 cm
Museo Nacional del Prado, Madrid

This work was also known as *The Tapestry Weavers of Santa Isabella in Madrid*. In 1948, it became apparent that the painting had not been executed for the king but for Don Pedro de Arce, one of his hunt masters, and only entered the royal collections in the eighteenth century. The subject matter was later recognized as the myth of Arachne, the young tapestry weaver from Lydia, who challenged the goddess Minerva to weave a tapestry and, on winning the contest, was turned into a spider (Ovid, *Metamorphoses*, Book 6)—Minerva sentencing Arachne is depicted in the background. Yet again, Velázquez has rendered this simple composition with consummate skill. As previously attempted and then employed during his early works, this again appears to be a "painting within a painting." There is a very realistic depiction of the spinners at work in the foreground (the two seated women are drawn from Michelangelo's paintings in the Sistine Chapel); the winder is driving the spinning wheel so fast that its spokes have become invisible and the hand operating the device is a mere blob of color. The sentencing scene in the background is portrayed in a different space, up several steps. Here, three figures in seventeenth-century clothing (one of whom appears to be turning towards the observer) seem to be the link between the depiction of the weavers and the depiction of the myth.

A cello is shown leaning up against a stool on the left, representing the restoration of harmony and the punishment of rebellion, an allusion to the Spanish political situation. The tapestry in the background is a copy of Titian's *Rape of Europe*, which was in the royal collections at the time.

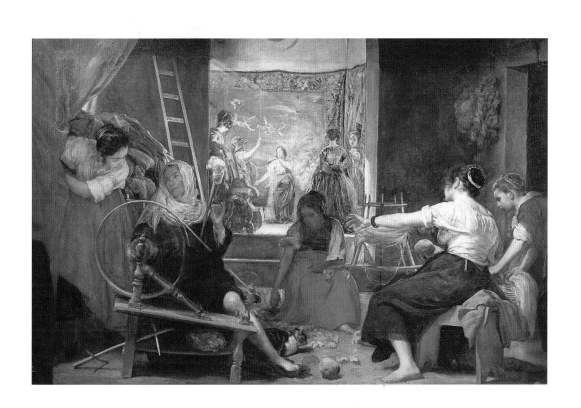

Infante Felipe Próspero

1659

Oil on canvas, 125 x 99.5 cm
Kunsthistorisches Museum, Vienna

Felipe Próspero was only two years old and the young heir to the throne at the time this portrait was painted. He was born in 1657 of the marriage between Philip IV and Mariana of Austria. It is an extremely fine late portrait by Velázquez, and although he respected the official nature of the commission, he included several extremely sentimental elements, apprehension over the little prince's poor health giving way to sadness after his death (in 1661). Although this is a portrait of a child, some elements of court portraiture remain, such as the significant full-length pose and various details, such as the armchair on which the little boy's hand is resting, a traditional Hapsburg connotation of power. A puppy is curled up on the chair, adding a note of familiarity and companionability for the child, whose dress betrays the unequivocal signs of his delicate state of health, such as pendants and amulets to ward off illness.

The painting is given depth by the open door in the background on the right, which reveals a differently lit room, allowing the painter to play with different shades of red, deliberately emphasizing the contrast with the white parts of the prince's clothing and the pallor of his face. The portrait of the heir to the throne was sent to Vienna in 1659, but the sickly little prince died before his fourth birthday.

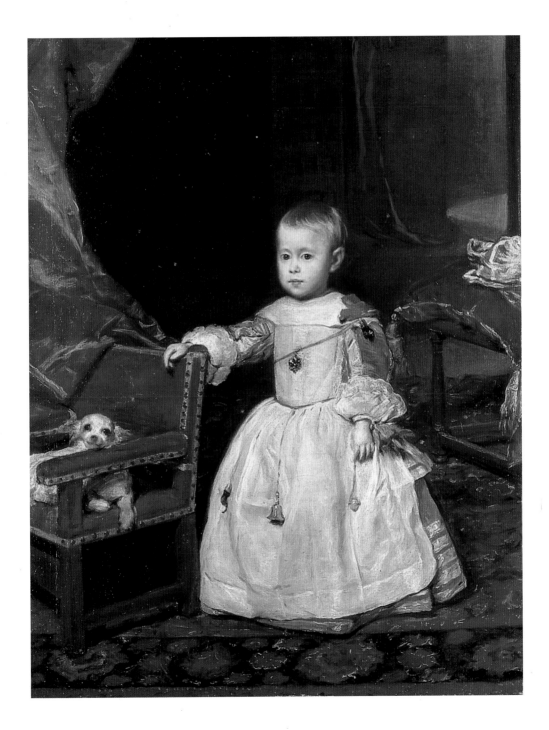

Infanta Margarita Teresa in a Blue Dress

1659

Oil on canvas, 127 x 107 cm
Kunsthistorisches Museum, Vienna

Of the many paintings of the Infanta Margarita Teresa at different ages, Velázquez's biographer, Palomino, tells us that this particular portrait was sent to Vienna in 1659, when she was eight years old, possibly along with the portrait of Prince Felipe Próspero. It is thought to be the last portrait Velázquez ever painted for the court of Philip IV and is now conserved in the Kunsthistorisches Museum, Vienna.

Although it retains all the classic elements of a regal portrait, the infanta was never to earn the right to the traditional symbols, such as a table, a clock, or an armchair on which to rest her hand. The background of the painting, however, contains discreet touches compatible with the delicate image of the young girl, such as the plain picture frame behind her head, a console table holding several fine ornaments, and a round mirror, possibly serving to identify a particular place in the king's private apartments. The regal bearing of the figure is unambiguous, the infanta no longer a young child, and is emphasized by her sumptuous clothes, the empty left glove held in her gloved right hand, and the stole held delicately in her left hand.

Even more striking than her dress, the girl's expression, no longer childish but shrewd, is the most compelling element, and is reminiscent of the impassive portraits of her mother Mariana.

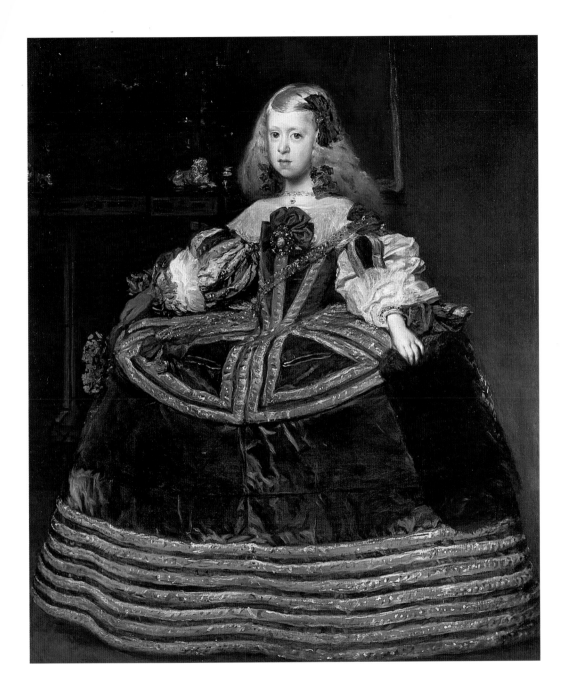

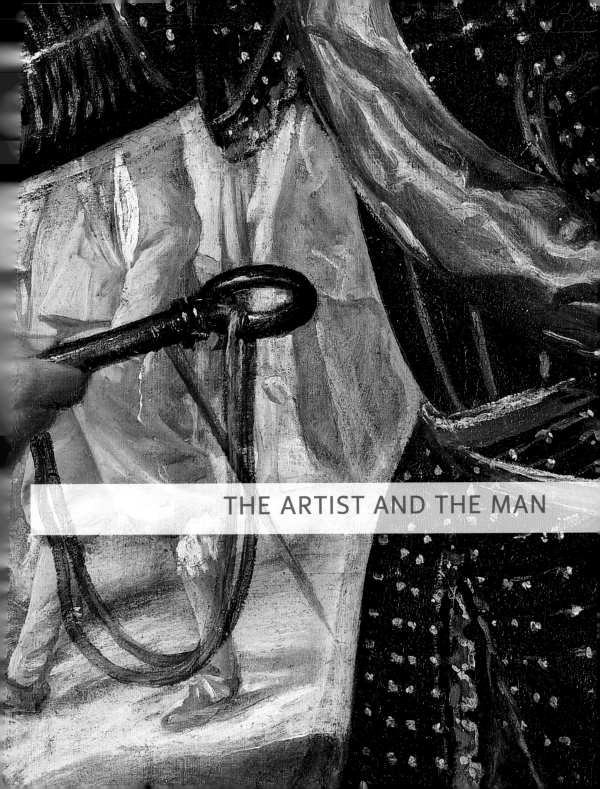

THE ARTIST AND THE MAN

Velázquez in Close-Up

His Technique, Step by Step

By the seventeenth century the Spanish artists had become more accustomed to using canvas rather than wood panels for their paintings. It was certainly a good deal more practical and manageable, especially where large-scale works were concerned. For Velázquez, too, the very first step towards making a painting consisted of carefully choosing the most appropriate canvas, in the awareness that the different weaves could well impact on the final outcome. Velázquez preferred to use linen and hemp canvases and, although he used both equally at the beginning and end of his career, he seems to have opted for linen predominantly during the middle years. When he started out as a painter during those early years in Seville, his preferred canvas was what was known in Spain as "a tovaglietta" because of the checkered pattern made by the weft and the warp. The advantage of this canvas, which originally came from Venice, was the relief effect it produced under the light, a quality that Velázquez used to great advantage in the end result of his work. He changed to taffeta canvas, which was a different, very plain canvas with a uniform, dense texture, after his arrival in Madrid and continued to use it until very late on in his career. Once he had chosen his canvas, it had to be seasoned before he could apply any paint to it. In his early Spanish works, he tended simply to go for a medium ocher color, described by Pacheco as "tierra de Sevilla" and by his biographer Palomino as "sludge." The consistency was achieved through a mixture of iron oxide pigments and small amounts of charcoal and calcite. Just as he had changed to a different type of canvas when he got to Madrid, Velázquez also changed his primer to the "clay" or earthy, characteristically red "tierra de Esquivias" then popular with painters in Madrid. In particular, for several of his early works in Madrid, Velázquez appears to have applied two different primers, laid one on top of the other. The first was a whitish solution, of varying thickness, based on calcite and organic black, well-impregnated with viscous binding material; the second was a reddish layer made from red and orange iron oxide, calcite, and red lake. This served as the real primer, because it was this layer that laid the ground for the basic chromatic effect and meant that there would be no visual blanks due to the transparency of the bottom layer, which served to prepare the canvas and make it waterproof. This red layer is more like an actual layer of paint than a primer in terms of both characteristics and function. Velázquez did, in fact, employ it in a painterly manner, allowing it to bring an added element to many other tonal effects. The real change, however, took place in around 1630, about the time he went to Italy. His direct acquaintance with Italian artists clearly triggered his decision to abandon the "Sevillan" ocher primer in favor of a lead white base. It was a practice Velázquez had already encountered, having been embraced by some of the earlier portraitists at the court of Madrid, but he only took it up wholeheartedly after his Italian sojourn, having observed it firsthand and at length. Careful study of his works dated around 1630 has shown that a substantial lead white layer

features above the reddish one, which serves not just to nullify its tonal effects, but also to create an extraordinary luminous visual ground that was to become increasingly transparent over the course of his career. This suggests that he may well have taken some of his own particular partly seasoned canvases with him and worked them up either during his Italian sojourn or afterwards, on his return to Spain. This primer, which was later to consist of lead white mixed with small amounts of different colored pigments, ranging from grays to pale brown (as well as a certain amount of pure lead white), was applied with a fairly large spatula. Curiously, although he never gave up this procedure, there was a certain irregularity in its application: carefully applied in his religious paintings, it was noticeably uneven in the large canvas for *Las Meninas* (ca. 1656, Prado, Madrid). The next step was to sketch the basic lines, simply tracing the outlines of the figures (this process can fortunately be deduced from those few works left unfinished, the *Portrait of a Young Man* in the Alte Pinakothek, Munich, ca. 1629, and *The Needlewoman* in the National Gallery in Washington, D.C., ca.1640–50, for instance, with the same skilled application of color and lack of preparatory drawing. The backgrounds, whether interiors, neutral spaces, or landscapes, were painted in later, once the figures were complete. Sometimes he left a tiny gap between the background and the figures, which still, to this day, allows the primer to show through in some cases. This method meant that there was no risk of his covering up or "sullying" the outlines of the figure.

Naturally, his procedure for the final coat which, despite holding few surprises, reveals the most fascinating side of Velázquez. It is here that his originality, his skill, his disregard for tradition—his art, basically—really shines through. His palette was always somewhat limited and he largely stuck to the same few pigments throughout his career. All he needed was white (made up of lead white and calcite), yellow (yellow iron oxide, lead-tin yellow, and, very occasionally, Naples yellow), orange (orange iron oxide and mercury-based vermilion), red (red iron oxide, mercury-based vermilion, and organic red lake), blue (azurite, lapis lazuli, and enamel), brown (brown iron oxide, and manganese oxide), black (organic plant or animal black), green (azurite, iron oxide, lead-tin yellow), and purple (organic red lake and azurite). Although he never changed the actual colors he used, what he did frequently change was the manner in which they were mixed, ground, and applied to the canvas. He was probably never overly concerned with pandering to traditional academism and even less concerned about following paint mixing recipes, unlike his master and then father-in-law Pacheco. Naturally there is no doubt that Velázquez was fully aware of both theoretical and applicatory tradition, but he wanted to find his own particular technique and then use it to achieve particular results, thus setting himself apart from his contemporaries through his own application of traditional techniques. The fact that he worked with a limited palette meant that he occasionally produced extremely masterful results, through the use of various shades

of just a few colors, such as in the *Coronation of the Virgin* (ca. 1635, Prado, Madrid) or his painting of Aesop (ca. 1638, Prado, Madrid), and later on in his last portraits of the Infanta Margarita Teresa (1659, Kunsthistorisches Museum Vienna; and 1659, Prado, Madrid), the former entirely formulated from shades of blue and the other from shades of red and orange. An analysis of the pigments also reveals alterations in the preparation of his colors. The grinding process, which was initially fairly careful, became extremely precise around the 1630s, and then the powder became steadily less fine, increasingly bulky, and eventually granular in later years. The pigments were combined with oily binding materials, which determined the transparency of the layers of color according to quantity. Velázquez constantly strove to achieve successful effects of color transparency and pictorial fluidity. To this end he was in the habit of adding small amounts of calcite and enamel to his colors. These enabled him to make freer, more fluid brushstrokes, which also allowed for a certain rapidity of execution, especially in larger works, while not jeopardizing the success of the work. It would appear that he first experimented with this system when executing the large works for the Hall of Realms. Clearly he was attempting to find a means of representing what he himself could see, and his quest for naturalism did not stop at his magisterial use of light; he also experimented with several unusual devices, such as the "casual" traces almost always found just under the painted surface, brought to light by modern X-ray equipment. The purpose of these marks

appears to have been to bring movement to the composition, although the lay observer might be forgiven for thinking that they had been generated by a careless movement by the artist while cleaning or flicking a bit of paint off his paintbrush, or even trying out colors directly on the canvas. Whatever the reason, it is less interesting than the fact that this process became a habit that Velázquez was to keep up throughout his career. When he finally got to the stage of actually painting, he probably did not have the overall composition worked out: his approach was to proceed in a manner that would allow him to see how the work might evolve, with the leeway to make alterations or changes to his basic idea. All this is still visible with the naked eye, in several pentimenti, usually in the outlines of his figures (position of the hands, the width of a sleeve, traces of movements). It is true that Velázquez's technique evolved through swift and fluid brushstrokes, absolutely unlike other artists of his time, but it is also true that this technique was intended to render a lifelike portrayal of the real thing. He was therefore innovative in his use of the sort of technical expedients to which no other painter of his time resorted.

A Rare Ability: Children's Portraits

Paintings of infants were fairly infrequent in the history of art as a whole, as well as in Velázquez's work. Although they made a reasonably frequent appearance in religious paintings depicting Christ's childhood, Velázquez did not paint many very young children. There is in fact only one

Christ child, in his *Adoration of the Magi* (1619, Prado, Madrid), for which he used his baby daughter Francisca as his model. The only other instance of a child in a religious painting is the slightly older one, representing the Christian Soul in his painting of *Christ after the Flagellation* (1628–29, National Gallery, London). Apart from two children featured in his early Sevillan works, too old really to be considered within the context of infant portraits, all the other children painted by Velázquez belonged to court circles, and none featured in religious or idealistic paintings, nor were they used as models for symbolic figures or memorial works.

Velázquez's courtly duties brought him honor and duties, the latter including the obligation to paint official and showy portraits of each member of the royal family, preferably without departing too far from the traditional codes of portraiture. Thus, during the period which saw a burgeoning interest in children's portraits, Velázquez was also asked to paint portraits of this kind. These he endeavored, where possible, to rid of their official aura, and imbue them at least with a carefree spirit. In the case of the portraits of the heir to the throne, Prince Baltasar Carlos, for example, the painter's attempts to cast etiquette aside are evident even in the first portrait Velázquez made of him on his return from Rome (1631–34, Museum of Fine Arts, Boston), by which time his subject was already one year and four months old. The contrast between his stiff, official, and solemn pose, in an elevated position with all the appropriate attributes for an heir to the throne, seems to be somewhat blunted by the sweet unquestionably childlike gaze and the fact that the painter was making use of the dwarf (male or female, since the identification of this figure as Francisco Lezcano, the prince's own dwarf, is now in doubt), the only moving figure in the double portrait, to hold objects that suggest play, diversion, and pretense but which in fact render it even more impossible to imagine a carefree infancy for Baltasar Carlos. His later portraits became gradually less formal; the portrait of *Prince Baltasar Carlos in Silver* (circa 1633, Wallace Collection, London), still full-length, with all the requisite attributes, but seen on his own, not accompanied by court dwarves, denotes almost more attention to the child than to the heir to the throne. The little boy's dark, vivacious eyes imbue his face with such sweetness that he seems to be on the point of breaking into an innocent smile at who knows what pleasurable thought. The equestrian portrait is quite different, however. Executed as part of the decoration for the Hall of Realms at the Buen Retiro, it served the same function as those of Philip II and Philip IV and their queens, which was to celebrate the Hapsburg dynasty in Spain, the expression on the boy's face is absolutely impassive. Luckily, some of the pastimes the royal family engaged in were well suited to pictorial documentation, the sort of pursuits available only to those at the very top of the social echelons, of course, such as hunting. Velázquez was able to portray the male members of the royal family in sporting attire, hunting costume, and accompanied by their dogs for the Torre de la Parada hunting lodge. He was

thus able to paint the heir to the throne, now aged six, completely naturally (*Prince Baltasar Carlos as a Hunter*, 1635–36, Prado, Madrid), newly serene, and outgoing-looking, as befitted his age, free from the burden of inheritance, which actually never came to fruition because of his early death. The Infanta Margarita, born in 1651, was the child most frequently painted by Velázquez. Her constant presence in court portraits is owed to various different factors. First and foremost the affection felt for her by the king, despite the fact that she was female and thus could never succeed to the throne (the kingdom was teetering on the brink of great crisis), the fact that she was not "overshadowed" by a brother, who would have been the heir to the throne and thus more important than she, and the fact that her birth had followed a period of deep mourning for the king meant that he saw her as a sign of hope for the future. Margarita, who was promised to her cousin Leopold of Hapsburg, also had her portrait painted at least once a year so that up-to-date likenesses could be sent to her future husband (the marriage took place in 1666). Thus the portraits give us an overview of the infanta as she grew up—by the age of three, she already looks perfectly at home in her role as a little princess (*Infanta Margarita Teresa in a Pink Dress*, ca. 1653–54, Kunsthistorisches Museum, Vienna), but it is interesting to see just how greatly and in what particular situations the painter allows her infant sweetness to shine through, just as it would have struck both the king and himself. The most significant example of this is the eruption of the young Margarita into his studio, followed by her maids of honor, followed in turn by the court dwarves (*Las Meninas*, ca. 1656, Prado, Madrid). The dewy portrait of a child within the context of a very complex work tells us a great many things: her easy relationship with the painter, the freedom to cast off etiquette (and presumably also the rules, as would any child), the wish to play at being grown-up (watching her eyeing up her parents as they pose, she surely seems to give the impression of wanting to imitate them), and an expression of canny innocence, looking as if she is trying to work out just how far she can go. Another work, the portrait of the little Infante Felipe Próspero (1659, Kunsthistorisches Museum, Vienna) should also be singled out. His birth in 1658 awakened fresh hopes of an heir in the king, who showered him with affection, fatherly love, and tenderness, tinged also with huge concern because the little prince soon turned out to be an irredeemably frail and sickly child. His portrait is one of Velázquez's last works, and manages to capture the fragility of the child in a particularly delicate and sensitive manner, especially as tradition has it that the boy not only had major health problems but was also a difficult child, fearful and extremely capricious. It is said that he would not allow anyone to pick him up, apart from an elderly Franciscan monk who was not steady on his feet either, like the prince who suffered from rickets, but that this was permitted and accepted by the king simply because of his great respect for the monk and his affection for the child.

Marriage

This is not an attempt to sensationalize but to document the life of an artist about whose training, artistic development, and social ascent much is known, while little is known about his private life and family. We know the names of his closest relatives, his father-in-law Francisco Pacheco, who played a pivotal part in his training and career, his wife Juana and child Francisca. A small volume of "Assorted Poems" put together by Francisco Pacheco, himself rather a second-rate poet, contains the only contemporary documentation of Velázquez's marriage, which took place on April 23, 1618, in the church of San Miguel in Seville. The value of this work is that it reproduces, presumably faithfully (despite being in a more literary vein), the cultural, literary, and artistic world surrounding Velázquez's early training. Or rather, perhaps, a cultural environment seen from the inside, which on one hand sparks the curiosity of the modern reader and on the other is faintly disappointing in that it is necessarily lightweight. The Pacheco home was the venue for meetings of poets and literary figures, some of whom are listed in the marriage poem, including Francisco de Rioja, poet and erudite Sevillan, Dr. Sebastián de Acosta, and Brother Pedro de Frómesta, a Carmelite monk. These people, mentioned and lauded for being at the Pacheco home on the occasion of the marriage of his daughter Juana were all great friends of his and were part, along with other cited but unidentified well-known figures, of the Sevillan cultural world, the group that often met at his house to talk about art. Baltasar de Cepeda, also a poet and scholar, tells us that all these people were engaged in a highly cultural discussion during the wedding party, which was probably the norm for the participants, but he makes only one reference to the subjects covered, almost a catalogue of erudition in its own right: the martyrdom of Saint Hermenegild, the nationality of Saint James, who seems to have been neither a Galician nor indeed Spanish at all, the mystery of the Eucharist—all deep, wide-ranging subjects discussed by the guests with the informed use of the words of Saint Paul. After such an introduction, just as he might have been expected to enter into a discursion on the artistic themes of the day, we are left empty-handed, having been led to expect a description of the works hanging in the Pacheco home. After dwelling on various conversational matters, the author describes being struck dumb on seeing the "small amphitheater" because "any mute who truly looked into his paintings / would have observed some to speak" as if the subject of the painting were capable of saying "here I am even though I am just a portrait." However, no single work is described and no artists mentioned. Thus, precious little is given about the cultural framework surrounding the marriage of Diego Velázquez, and the following verse continues with a description of the wedding breakfast "with God's blessing, and plenty to eat and drink," entertainment provided by a jester, music, and toasts, as at all respectable parties.

Elevation to the Rank of Knight of the Order of Santiago

On June 12, 1658, the official decree entitling Diego Velázquez to wear the uniform of the Military Order of Santiago finally came through. This privilege, which came into being through the enactment of the aforementioned royal decree, took almost a year to secure and was greatly facilitated by a Papal stamp exonerating the candidate from having to comply with the three-quarters nobility rule, to which the painter could not justly lay claim. Velázquez, the king's own painter, thus achieved total recognition not just of his art, which was much appreciated and incontestable, but also of himself as a man, with an official conferral of nobility that took him to the highest social rank he could possibly ever have aspired to. It is well known that this recognition was no easy matter and that Velázquez knew full well that he would have had to fight hard to find the right support for his cause during his second visit to Italy. This was clearly a huge step, and a hugely important one for a Spanish artist. His achievement signaled the need to accord a different social rank to artists, who were still seen in a traditional, medieval light. Velázquez's knighthood came about thanks to the intervention of both king and pope, and he was able to enjoy the fruits of his success. His friendship with the king, which had matured over such a lengthy period of service, meant that although his belonging to the Order was rather anomalous, it did at least befit his personal situation. Being a knight of the ancient Order of Santiago was indeed a great honor, but it also brought with it certain duties, most of which Velázquez was excused from. Item V of chapter 9 of the "Rules and Constitutions" of the Order of Santiago states that one year after being admitted to the Order novices had do six months' prison work and then enter one of the monasteries belonging to the Order. The same item specifies that anyone in the service of the king and working for a just cause could be let off with a written and signed dispensation. Diego Velázquez was able to be excused his six months' apprenticeship and from having to choose a monastery after being sworn in as palace marshal on March 8, 1652. All this came at some cost, however. Knights were required to pay 115 ducats for contracts of this sort, 100 for the "media anata," the set fees for ecclesiastical and lay privileges, plus the outlays for presenting the requisite proof, 300 silver ducats, and obtaining the pontifical seal: there is a record of a first installment of 454 reals being paid, followed by more hefty fees amounting to over 380 silver reals. Last of all, the travel expenses of the officials required to carry out all the checks had to be paid ("450 silver ducats plus 300 for the cavalier and 55 for the brother"). This was an honor Velázquez had long coveted and, as we know, he was keen to broadcast it by painting the red cross of the Order (some say that it was in fact painted by the king himself) on his smock in the painting of *Las Meninas*, which enabled him to be buried with great pomp and ceremony in his knight's uniform after his death.

Velázquez's Library

The inventory of Velázquez's assets drawn up by his son-in-law and pupil Juan Bautista Martínez del Mazo and his friend Gaspar de Fuensalida on August 29, 1660, a few days after his death, tells us which books were in his library and therefore what his interests aside from art were, his personal sources of preparation and study, and what he read for pleasure. There were a great many poetry books, 156 of which are listed, but there may have been a good deal more if all those listed under the heading of "Poetas" consisted of different works. Velázquez appears to have been particularly interested in the sciences, acquiring works on mathematics, medicine, cosmography, and the natural sciences. He also owned books in Spanish, Italian, French, and Latin, as well as a Spanish-Italian dictionary and a Latin-Spanish dictionary, which suggests that he had some degree of familiarity with the Romance languages. Although there appeared to be gaps in what one might have expected to be a "typical library" for an artist well-ensconced in cultural circles, it is worth remembering that he had almost unparalleled access to a vast quantity books by dint of living at court and it is highly likely that not all the volumes he consulted belonged to him or formed part of his library. This is particularly true of the marked absence of devotional and theological texts which, when the inventory was published (in 1942), caused various critics to suggest that he was not a particularly religious man, more interested in magic and the occult. A careful study of the works in his possession, particularly those written in Spanish, shows that there was also a striking paucity of works by the great authors of his day, some of them still regarded as landmarks of Spanish literature.

The only Spanish work of fiction seems to have been *Auroras de Diana*, a novella by Don Pedro de Castro y Anaya, first published in Madrid in 1631. Notwithstanding the many possible theories that might justify this odd addition to his library (it has been suggested that as the Coimbra 1654 edition was edited by Donna Maria de Silva, a nun at the Santa Chiara convent in Coimbra, she might have been the link he was seeking in order to prove the noble origins denied to the de Silva branch of the family) or it could have been a result of their friendship through their various links with Italy (which Velázquez always remembered fondly) mentioned in the volume. However, there is also the possibility that works by some of the great names of the Spanish Golden Age were simply catalogued under the heading "Poetas," which might well encompass several works by renowned poets, or it could simply refer to the title of a well-known 1605 anthology, *Flores de poetas ilustres de España*. The poetical works, which were in truth considerably fewer than one might have expected to find in Velázquez's library, included Italian-language editions of a work by Petrarch and Ariosto's *Orlando Furioso*; it also included two versions of Ovid's *Metamorphoses* and a Spanish translation of Horace. There were, however, two major aesthetic treatises by contemporary Spanish authors: *Philosophia antigua poética* by Alonso López

Pinciano, published in Madrid in 1596, and Juan Díaz Rengifo's *Arte poética española, con una fertilísima silva de consonantes,* published in Salamanca in 1592. It was in Pinciano's work that Diego Velázquez would mostly have found aesthetic remarks in praise of art and painting with short maxims, such as, for example, "art is a way of doing things wisely." One might well have expected a Spanish artist immersed in the Golden Age, and a pupil of the treatise writer Francisco Pacheco to boot, to have owned a great many religious and devotional texts, but he appears to have had very few, and those that there were included only one single book in Spanish, *De la Pasión de nuestro Señor,* by Canon Lucas de Soria, first published in Seville in 1614. There were, however, many works on astrology and the occult sciences, and their presence in Velázquez's library is a testament to the dualism of his training and interests, along with mathematics and natural science, despite being their complete opposite. Works such as Antonio Náxera's *Summa astrológica* (published in Lisbon in 1632) would have proved useful for learning how to make predictions, and the leading work on mythology available in Spain during the seventeenth century, Bachiller Juan Pérez de Moya's *Philosophia Secreta, donde debajo de Historias fabulosas se contiene mucha doctrina provechosa a todos estudios, con el origen de los ídolos o dioses de la gentilidad* (published in Madrid in 1585), the subtitle of which contained the note "this material is essential to understanding poets and historians," were undoubtedly useful works for a painter and not necessarily out of the ordinary

for the cultural environment of the time. The treatises included an Italian work by Giambattista della Porta, *De humana physiognomonia* (published in Naples in 1586). There were also two tracts on iconology, one by Cesare Ripa (the first edition was published in Rome in 1573) and another listed as being the work of one Peregrino, which was probably the slightly earlier of the two, entitled *Pitture del Doni, Accademico Pellegrino* (published in Padua in 1564), both probably still unillustrated editions. There were a multitude of scientific works, ranging from mathematics to geometry (*Arithmetica de Moya, intitulada manual de contadores,* published in 1582; *Libro de algebra en aritmética y geometría,* by the great cosmographer then in the service of the king of Portugal, Pedro Nunes, published between 1564 and 1567), the knowledge of applied geometry being crucial for the correct use of perspective, clearly learned from works such as Juan de Alzega's *Libro de geometría práctica* (1580) and *Elementos geométricos de Euclides, filósofo megarense,* published in Alcalá in 1637. One of the major influences in this sphere would have been works by authors such as the Frenchman Jacques Besson, in this case in the version translated from Latin by Francisco Berolado, *Teatro del los instrumentos y figuras matemáticas y mecánicas,* or the *Libro de instrumentos nuevos de geometría muy necesario para medir distancias y alturas sin que intervenga números,* by Andrés Cespedes, chief cosmographer to the king of Spain (published in Madrid in 1606). There were plenty of cosmographical and nautical works listed in the inventory, while the scientific section was

rounded off by works on natural science, such as Pliny's *Naturalis Historia* in both the Latin and Italian versions; listed along with Spanish anatomical works (*Libro de la anatomía del hombre*, by Benardino Montaña de Monserrate, of 1551), and texts such as Dürer's *On the Symmetry of Human Bodies* (1594) and an anatomical treatise by the Flemish doctor Andreas Vesalius. There were also several medical books and other classical works that would have been of interest to him not just as an artist but with regard to the moral and political formation of men and courtiers, particularly as he was keen to be ennobled. He owned Spanish editions of Aristotle's *Ethics* and *Politics* and two Italian editions of Baldassare Castiglione's *Il libro del cortegiano*. His books included works on chivalry in both Italian and Spanish, but there were very few on either contemporary or ancient history, and those there were tended to be in Italian rather than in Spanish. His limited interest in the ancient world is also evidenced by the fact that he read very little about it, the only works on antiquity were a text by Livy, Gabriel Simeoni's Italian translation of the *Discours de la religion des anciens Romains* by Guillaume du Choul, published in Lyons in 1567, and *Le Imagini ... degli Imperatori tratte dalle Medaglie*, by Antonio Zantani (1584). However, there were also works that were of direct interest to the artist. Those discussed thus far touch on the many and varied interests that a man such as Velázquez might have had, which naturally also relate to his work, although not directly inherent to them. Most of the books in Italian dealt with the subject of art:

Rusconi's treatise on architecture (*I dieci libri di architettura di Gio. Antonio Rusconi, secondo i precetti di Vitruvio*, Venice, 1660), Vincenzo Scamozzi (*La idea dell'architettura universale*, Venice, 1615), Cattaneus (*I quattro primi libri di architettura, di Pietro Cataneo*, Venice, 1554), Giovanni Battista Montano (*Architettura con diversi ornamenti cavati dall'antico*, Rome, 1636), Busca (*Della architettura militare di Gabriello Busca*, Milan, 1601), Palladio (*I Quattro libri dell'architettura*, Venice, 1570), Bassi (*Dispareri in materia d'architettura, et perspettiva. Con pareri di eccellenti, et famosi architetti, che li risolvono*, Brescia, 1572), Fontana (*Del modo del trasportare l'obelisco vaticano*, Rome, 1589). There were some works in Spanish, however, such as the Castilian translation of Vitruvius by Miguel de Urrea, and Francisco Lozano's translation of Leon Battista Alberti's *De re aedificatoria*; Velázquez also owned Spanish translations of the works of Serlio and Vignola. Why an artist's library should contain so many treatises on architecture, including minor ones, remains something of a mystery. There was still a large preponderance of books by Italian authors, including untranslated ones, even on the subject of painting or sculpture. These included works by Leonardo da Vinci (*Trattato della pitture*) and on Michelangelo, Vasari's *Le Vite de' più eccellenti pittori, scultori, ed architettori*, Barbaro (*La pratica della perspettiva*, published in Venice in 1568), as well as Federico Zuccari (*L'Idea de' pittori, scultori et architetti*, published in Turin, 1607, in two volumes). There were another two books in Spanish on the same subjects: *De Varia conmensuración para la escultura y arquitectura*,

by Juan de Arfe, published in Seville between 1585 and 1587, and, needless to say, *Arte de la pintura, su antigüedad y grandezas*, published in Seville in 1649 by his master and father-in-law Francisco Pacheco.

Velázquez's bookshelves also included folders of prints and drawings, all relating to paintings and sculptures. Finally, there was a particularly curious Spanish work on the nobility of art and artists, published in Salamanca in 1600, which would have come in handy as he prepared for his imminent elevation to the Order of the Knights of Santiago.

Pomp and Circumstance for the King's Painter

Everything came to an end with the death of Velázquez, apart from the remembrances for those who live on. Diego Velázquez's funeral was all and more that might have been expected in the light of his life as an artist and court painter. The exceptional lavishness of the arrangements, as described in Palomino's biography, was quite unique for an artist in seventeenth-century Spain. Palomino quite naturally points out that this sort of funeral was not comparable to what might have been expected for a member of the royal family, but that it did bear witness to his acquired nobility and also to his importance as an artist. However, it is fair to say that, as discussion was still raging at the time over the social position of artists in Spain, who were still ranked on the same level as crafts-men, most of the pomp and ceremony was actually ac-corded to him not because of having been an artist, but because he had been a knight of Santiago. One of the things that Palomino's account underscores is the presence of many noblemen and cavaliers belonging to the court and in the service of the king at the funeral, although the king himself was not present despite his ad-miration for and friendship with Velázquez, because it would have flown fiercely in the face of etiquette. As had been the practice for some time in Spain at grand funerals, Diego Velázquez was also provided with an impressive catafalque, lit by a multitude of candles and silver candle-sticks, an extremely solemn mass with marvelous music and voices and instruments "that were the custom for such important occasions."

Portraits of Court Dogs

As a court artist, Velázquez proved a skillful interpreter of the tastes and predilections of the royal family. As was usual for the time, dogs were an integral part of any portraits of kings, princes, and those moving in court circles. Dogs were the indispensible companions of the seventeenth-century sovereigns, especially those with a passion for hunting. The inclusion of animals, particularly those of certain breeds, was not just accepted practice in official portraits, but very much requested. Velázquez painted different breeds of dogs and dogs of all sizes, in a wide variety of attitudes, again carrying forward the tradition Titian had launched with Charles V, with great aplomb.

Placid hunting dogs appear alongside their respective owners in the portraits of the royal family made for the

decoration for the Torre de la Parada hunting lodge and now in the Prado, while a lively spitz, an ideal playmate for the Spanish children, peeps out of the portrait of Prince Felipe Próspero now in the Kunsthistorisches Museum in Vienna. There is a striking contrast between the rather alarming size and absolute docility of the perfectly behaved Molossian Mastiff (or Spanish Great Dane) in *Las Meninas*, Velázquez's famous court scene, who fails to react even when an unruly page aims a kick at it. This excessive display of patience and "loyalty," unmoved by provocation, was not unconditionally appreciated and in fact caused no little irritation among the literary figures of the time. There is a famous verse in Shakespeare comparing a spaniel curled up at his master's feet to servile courtiers and their lords. Although the simultaneous presence of large dogs and dwarves had long been a tradition in the European courts, it is also possible that the painter had wished to underscore the unpredictable variety of nature by placing the huge mastiff and Maribárbola, the female dwarf, next to each other. He had previously experimented with this sort of play on dimensions in the portrait of Don Antonio, one of the court jesters in Madrid, a dwarf nicknamed "the Englishman," who with a smug expression and a rather defiant glare is holding onto the lead of a powerful female mastiff, a good deal taller than he.

A Disenchanted "Classicist": His Relationship with the Old

Spanish painters of the seventeenth century had less occasion to engage with mythological subjects or ancient historical ones than their counterparts in the rest of Europe. When they did, however, their interpretation of the classical world was a singular and powerfully satirical one. In a strongly Catholic country, the great Spanish literature of the time (Góngora, Lope de Vega, and Cervantes) tended to portray them as rather banal, endowing them with prosaic customs and feelings, almost to the point of vulgarity. Velázquez too was wont to treat mythological subjects in a profane and denigrating manner, stripping them of any literary grandeur or pomp. Thus both Menippus and Aesop look more like scruffy, knockabout bohemians; his mustachioed Mars looks more like a puffing sergeant than a god of war; his mythical Arachne is surrounded by the bustle of a textile factory, and Vulcan's forge looks just like a blacksmith's workshop; the painting of Mercury and Argos looks more like a depiction of a warm summer's day in the country, and the unforgettable *borrachos*, the drunken, toothless, grinning companions of Bacchus, combine to bring the myth down to the level of a simple, banal, yet hearty scene of peasant life. His splendid rear view of Venus, however, is simply enchanting, and was the only—and stupendous—female nude that Diego Velázquez painted in his entire career.

Anthology

My son-in-law, Diego Velázquez de Silva was educated in this doctrine [drawing] as well; while still a boy he bribed a fellow apprentice to serve as a model in various actions and postures: sometimes crying, sometimes laughing, without excusing any difficulty of drawing. He made many heads of this boy in charcoal and highlight on blue paper, as well as many others from life, with which he gained great assurance in portraiture.

Francisco Pacheco
Arte de la pintura: Su antigüedad y grandeza (The Art of Painting), 1649

Some reproached him for not painting with delicacy and beauty more serious subjects in which he might emulate Raphael of Urbino, and he replied politely by saying that he preferred to be the first in that sort of coarseness than second in delicacy.

Antonio Palomino
El museo pictórico y escala óptica (Lives of Velázquez), 1724

[Velázquez] had such mastery in execution particularly in his picture of *Las Hilanderas* that this work seemed to have been painted not by the hand but by the pure force of will.

Anton Raphael Mengs
Letter to Antonio Ponz, 1776

It is generally agreed that Velázquez's excellence does not lie in his philosophical or ideal genius for painting, but in his imitation of nature. In a classification of painters, he must therefore be ranked among the "naturalists"; those

who, without departing from the ideal notion of beauty, seek it in nature, just as it exists there, aspiring only to transferring it whole to their pictures.

Gaspar Melchor de Jovellanos
Reflexiones y conjeturas sobre el boceto original del cuadro llamado "La Familia," 1789

This is what I have so long sought, this firm, yet yielding impasto.

Eugène Delacroix
Journal, 1824

Velázquez is not just a great master, in the usual sense of the word, because of his genius, his talent, his success, and all the other qualities that mark out a leading artist. He is a great master (or rather, one of the greatest, not to say the greatest from a certain point of view) even if we take the word to mean a teacher, an educator in the art of painting. Let us try and clarify the concept: on one hand, a pupil simply admiring his paintings and studying them intelligently, can learn a lesson from a past master; on the other, pupils can be continually advised to imitate nature, strictly, and above all; that constant model that can never be changed either by the vagaries of fashion, nor the excesses of individual style, nor by the arbitrary rules of later schools.

Louis Viardot
Les musées de France, 1855

How I miss you here. What a joy it would have been for you to see Velázquez which for him alone is worth the

trip. The painters of every school who surround him in the museum of Madrid, and who are all very well represented, seem completely like fakers. He is the painter of painters. He has astonished me, he has ravished me.

Édouard Manet
Letter from Madrid to Henri Fantin-Latour, 1865

He was the painter who best knew how to penetrate the Spanish soul, how to find the form and expression most attuned to the spirit of his people.... He painted with such skill and acumen, with such energy and precision, with such simplicity and representative force, that even the most masterly of painters feels tempted to break up their paintbrushes when confronted by his work.

Karl Justi
Velázquez und sein Jahrhundert, 1888

He is the prince of Spanish painters and one of the best in the world.... All his works are dominated by aerial perspective, atmosphere, and light; he accords true value to his hues; and he employs color to set the boundaries and distances with the same precision as might be expected of the inflexible rules of perspective.... His great works owe nothing to anybody, and he has displayed no little admiration for the Venetian painters; they are born of his originality, his spontaneity, his sense of artistry. His constant study of the real thing gave him power over his drawing, and his fine eye enabled him to appreciate colors.... His good taste and elegance in rendering postures, expressions, and groups, with slenderness and grace, prevail in all his canvases.... He was not an artist given to large and complex themes, nor was he given to erudite research, or ardent spirit.... He was a superlative naturalist, painting just what he saw; he knew what he was painting and how to paint it.... His work was not conditioned by classical antiquity or the Renaissance; he believed that the real thing surpassed any book, model, or study; he did not hold with erudition, history, or horizons other than what could be seen with the naked eye. This is what makes Velázquez the painter, like Cervantes the author, so marvelously Spanish.

Gregorio Cruzada Villaamil
Anales de la vida y de las obras de Diego de Silva y Velázquez, 1885

Equally he is the most prolific technician and the most dangerous aesthete. One needs to study him in order to learn how to paint well; but one has to forget him in order to become an artist. He knew how to remain a great gentleman in the art that he almost carried to vulgarity. A Dutchman of sorts, but on a grand scale, borne up by an entirely Spanish gravity.

Émile Bernard
Sur l'art et sur les maîtres, 1922

Velázquez is like a crystal suspended over the world. Nothing respects veracity as much as crystals. Yet nothing runs so great a risk of leaving us to doubt whether or not it actually exists. No one in the world could allow themselves the luxury of reproaching Velázquez. He is what he is: calm, impassive, irresponsible. And his creatures,

devoid of any concerns of lightness or weight, are and remain what they are.

Eugenio d'Ors
Tres horas en el Museo del Prado, 1922

He did not have to deviate from nature for he could see the beautiful in nature. He painted with easy large movements, and his work has great finish combined with great looseness. His forms make beautiful rhythm. A silver light runs through his work. There is a violet note in the Spanish face.

Robert Henri
The Art Spirit, 1923

Velázquez's enduring, lynx-like infallibility, which is not mere naturalism but a personal way of seeing things with a breathtaking naturalness, is not given to many in art. That is to say a complex ability to grasp the most representational instant of natural appearance—not an instant planned for and codified as part of a canon of rhythmic or plastic worth ... quite the reverse, a wellspring of the cosmic efficacy of relationships suddenly lit up by the light and matter of things, which also happen to include man. A luministic and environmental worth that has deposed Renaissance humanism, and whose historical significance can never be stressed enough.

Roberto Longhi
Vita artistica, 1927

Austere painting, Castilian painting, concentrated painting, painting pregnant with interior light, space for space's sake, like art for art's sake.... Velázquez is the marker of the Spanish scales at a time when the scales were rising higher and held the gold of the Golden Age in its dishes. That is the perfect real plastic and golden equation.

Ramón Gómez de la Serna
Don Diego Velázquez, 1943

His range was somewhat restricted, but his knowledge of values grew with the years, and in the use of whites and silvery grays he had no rival. Where the Venetians would have clashed red against pink, rose against purple, Velázquez by some mysterious alchemy combined all without discord and created new color harmonies. From the Venetians he learned to break the rigid contour lines of his figures, and to shape forms with light, to sweep across the canvas grain with swift brush, placing accents where they were most needed. From the realism of the bodegónes to the impressionism of his last works was a long and arduous journey, the steady progress of a craftsman determined to master his trade rather than the effortless success of a virtuoso.

Elizabeth du Gué Trapier
Velázquez, 1948

His surviving early works show that his aim was to faithfully represent what he saw. His still lifes are realistic paintings that reveal his mastery of tactile values. He was probably acquainted with some works by Caravaggio and his followers; in any case he employed what we call "tenebrism" in many of his paintings, albeit in his own particular manner.

Throughout his career his compositions followed the schemes of the Mannerist painters; he never marked out his space along diagonal lines, save for some of his equestrian portraits. His move to Madrid, however, gave Velázquez an opportunity to study the great Venetian masters, and his style changed. His palette moved from browns to grays and blacks; he became more self-confident, learning how to represent movement.... Velázquez later went to Italy and made contact with the artists in that country, not just with those who had gone before, but also with artists still living and working. His range of colors expanded, increasingly enriching his future paintings. His brushstrokes became freer and more eloquent with each canvas he made, and he soon achieved a level of precision unique in European painting. His fervent late paintings are just as eloquent as those of the Oriental painters.

Xavier de Salas
Velázquez, 1962

It has sometimes been said that Velázquez was "spiritualized" in such a way that, while pre-eminently active in the century of Baroque, he seems like a "Classical [artist]" and even, despite being so very Spanish and immersed in his own age, a Greek from the era of Pericles. Surely, over and above however transitory and however brilliant and fictitious, Velázquez's painting, like Greek art, maintains a high level of equilibrium, sober elegance, serious depth, in the name of that beauty that flows, like clear water, from the eternal fountain of truth.

Bernardino de Pantorba
Tutta la pittura del Velázquez, 1964

Velázquez may be, may be forever, the most perfect example of the pure painter, that is, one who besides being gifted with a phenomenal eye also possesses the unerring hand that can freeze reality, suspending it within an instant of radiant life. The poet Rafael Alberti, in a poem describing the temperament of the master from Seville, writes: "In your hand a chisel would have become a brush; a brush, an ordinary brush, a bird on the wing."

Alonso E. Pérez Sánchez
Velázquez, 1989

Velázquez saw the world with fresh eyes, something few artists have ever been able to do. This original vision could be expressed with an original technique, thus he became an innovative practitioner of the art of painting.

Jonathan Brown and Carmen Garrido
Velázquez: The Technique of Genius, 1998

Velázquez's fame in Italy was as a painter under the protection of Philip IV, a master of the genre of portraiture. Before his second visit to Italy, the word from Madrid to various Italian courts largely concerned three matters: the difficulty in asking him for a portrait, because his palace duties left him little time to paint; the length of time it took him to complete his works; and the extremely high cost of the latter.

Salvador Salort Pons
Velázquez en Italia, 2002

Locations

The Jester Calabacillas, mistakenly
called Bobo de Coria, 1637–39
Aesop, ca. 1638
Menippus, 1639–40
Mars, ca. 1641
The Buffoon Sebastian de Morra,
ca. 1646
Mariana of Austria, ca. 1652
Felipe IV, ca. 1655
The Family of Felipe IV, or
Las Meninas, ca. 1656
The Fable of Arachne, or
Las Hilanderas, ca. 1657
The Infanta Margarita de Austria,
ca. 1659
Mercury and Argos, ca. 1659
Orihuela
Museo Diocesano di Arte Sacra
The Temptation of Saint Thomas
Aquinas, 1631–32
Seville
Museo de Bellas Artes
Saint Ildefonso Receiving the
Chasuble from the Virgin, 1623

UNITED KINGDOM
Edinburgh
The National Gallery of Scotland
An Old Woman Cooking Eggs,
1618
London
The National Gallery
Christ in the House of Martha and
Mary, 1618
Saint John the Evangelist on the
Island of Patmos, ca. 1618
The Immaculate Conception,
1618–19
Christ after the Flagellation
Contemplated by the Christian Soul,
1628–29
Philip IV of Spain in Brown and Silver,
ca. 1631–32
The Toilet of Venus ("The Rokeby
Venus"), 1647–51
The Wallace Collection
The Lady with a Fan, ca. 1640
Wellington Museum, Apsley House
The Waterseller of Seville, ca. 1620

UNITED STATES
Boston
Museum of Fine Arts
Don Baltasar Carlos with a Dwarf,
1632
New York
The Metropolitan Museum of Art
The Supper at Emmaus, 1622–23
Juan de Pareja, 1650
Washington, D.C.
National Gallery of Art
The Needlewoman, ca. 1640–50

Chronology

The following is a brief timeline of the major events in Velázquez's life, alongside the principal historical events of the period (in italics).

1599
Diego Rodríguez de Silva y Velázquez born in Seville, baptized in the church of San Pedro on June 6.

1600
Madrid: Birth of the playwright Pedro Calderón de la Barca.

1602
Madrid: King Carlos II summons Luca Giordano as court painter.

1603
Madrid: Peter Paul Rubens's first diplomatic mission to Spain on behalf of Vincenzo Gonzaga.

1605
Valladolid: Birth of Prince Philip, later King Philip IV, son of Philip III and Margarita.
Madrid: Part One of Cervantes' El ingenioso hidalgo don Quijote de la Mancha (Don Quixote) is published.

1607
Madrid: Spain bankrupted by colossal war costs.

1609
Diego Velázquez enters the workshop of Francisco Herrera the Elder.

Antwerp: Rubens appointed court painter to Albert and Isabella of Hapsburg, Sovereigns of the Southern Netherlands. Twelve Years' Truce between Spain, the United Provinces, England, and France begins. Holland becomes independent of Spain, which retains control over the Southern Provinces.

1610
December: Enters the workshop of Francisco Pacheco.

1615
Madrid: Part Two of Cervantes' El ingenioso hidalgo don Quijote de la Mancha (Don Quixote) is published.

1616
Madrid: Death of Miguel de Cervantes.

1617
March 14: Velázquez takes and passes the obligatory exam for all artists to practice autonomously, a requirement set by the Catholic monarchs.

1618
Diego Velázquez marries Juana Pacheco, his master's daughter, in the church of San Miguel in Seville.

1619
Birth of Francisca, the first child of Diego Velázquez and Juana Pacheco. Velázquez dates *Adoration of the Magi*.

Spain enters the Thirty Years War.

1621
Birth of Ignacia, second daughter of Diego Velázquez and Juana Pacheco.

Madrid: The Spanish court moves permanently from Valladolid to Madrid, chosen by Philip II as the imperial city in 1561.
Death of Philip III; Infante Felipe proclaimed King Philip IV, Count Gaspar Olivares appointed prime minister.

1622
Velázquez leaves Seville for the first time; portrait of the poet Luis de Góngora y Argote executed.

1623
Madrid: Diego Velázquez is introduced to court.

1625
Jubilee Year proclaimed by Pope Urban VIII.
June 5: Surrender of Breda.

1627
Cordoba: Death of the poet and playwright Luis de Góngora y Argote.

1628
Madrid: Diego Velázquez meets Peter Paul Rubens, on a diplomatic mission to Madrid for the ruler of Flanders, in an attempt to broker the end of the Thirty Years War.

1629
July 30: Diego Velázquez leaves Madrid for Barcelona, where he sets sail for Italy.

Birth of Prince Baltasar Carlos, heir to the throne. Peace between England

and Spain, partly due to the success of Peter Paul Rubens's diplomatic mission.

1630
June: Velázquez arrives in Rome where he is to spend a year, finding favor with Cardinal Francesco Barberini, nephew of Pope Urban VIII.

1633
Begins the decoration of Torre de la Parada, the hunting lodge near El Pardo.

Brussels: Death of Infanta Isabella of Spain.

1634
Work on the new Buen Retiro summer palace begins.

Catholic Low Countries are again under Spanish dominion. Philip IV appoints his brother Ferdinand as ruler.

1635
Diego Velázquez paints *The Surrender of Breda*, based on the politically significant event of ten years earlier.

Death of the writer Félix Lope de Vega in Madrid.
France declares war on Spain, entering the Thirty Years War.
Madrid: Publication of Calderón de la Barca's philosophical/theological drama La vida es sueño.

1637
The United Provinces take Breda from the Spanish.

1639
Seville: Francisco Pacheco dies.

1640
Spain: Autonomist revolt in Catalonia. The most violent clashes occur in Barcelona.
Madrid: Baltasar Gracián's El político (The Politician) published.

1641
The independentist conspiracy in Andalusia fails.
Portugal splits from Spain.
Madrid: Birth of the Infanta Margarita.

1644
Madrid: Death of Queen Isabella of Bourbon, first wife of Philip IV.
Rome: Cardinal Giovanni Battista Pamphilj elected Pope Innocent X.

1645
Germany: Peace of Westphalia negotiations begin.

1646
Madrid: Death of the heir to the Spanish throne, Prince Baltasar Carlos, aged seven.

1648
The architect Gómez de Mora dies in Madrid, leaving Velázquez in sole charge of the decorations for the Alcázar palace
November, Madrid: Diego Velázquez leaves for Italy for a second time.

Peace of Westphalia signed, bringing an end to the Thirty Years War.
Madrid: Posthumous publication of Francisco de Quevedo's El Parnaso español.
Rome: Pope Innocent X condemns the Westphalia treaties for not favoring but damaging Catholic interests.
Spain: Definitive recognition of the Low Countries.
Loses its highly advantageous continental position of power to France.

1649
Spain: Francisco Pacheco's Arte de la pintura published in Seville.
Madrid: Marriage of King Philip IV to his niece Mariana of Austria, daughter of his sister Maria Anna of Spain.

1650
Spain splits from Portugal and Catalonia.

1651
June: Return of Diego Velázquez to Madrid, bringing with him paintings and sculptures acquired on behalf of the king.

1652
Madrid: Diego Velázquez is appointed *aposentador mayor*, the king's palace marshal.

1655
Rome: Fabio Chigi elected Pope Alexander VII.

1658
June 12: Diego Velázquez is appointed knight of the Order of Santiago.

1659
Peace of the Pyrenees.

1660
August 6: Death of Diego Velázquez in Madrid.
August 7: Full court funeral.

Seville: Academia de Bellas Artes founded by Bartolomé Esteban Murillo.

Literature

Jeannine Baticle. Velázquez: *El pintor hidalgo*. Madrid, 1990.

Antonio Domínguez Ortíz et al. *Velázquez*. Exh. cat. Metropolitan Museum of Art. New York, 1990.

Francisco Calvo Seraller. *Las Meninas de Velázquez*. Madrid, 1995

Jonathan Brown. *Velázquez: Painter and Courtier*. New Haven and London, 1999.

Marcus B. Burke, ed. *Velázquez in New York Museums*. Exh. cat. Frick Collection. New York, 1999.

José López-Rey. Velázquez: *Catalogue Raisonné. Cologne*, 1999.

Fernando Marias. Velázquez: *Pintor y criado del rey*. Madrid, 1999.

Salvador Salort Pons. *Velázquez en Italia*. Madrid, 2002.

Andreas Prater. *Venus at her Mirror: Velázquez and the Art of Nude Painting*. Munich et al., 2002.

Jonathan Brown and Carmen Garrido. Velázquez: *The Technique of Genius*. New Haven and London, 2003.

Manet—Velázquez: The French Taste for Spanish Painting. Exh. cat. Musée d'Orsay, Paris and Metropolitan Museum of Art. New York, 2003.

Alfonso E. Pérez Sánchez, ed. *Velázquez en la corte de Felipe IV.* Madrid, 2003.

Dawson W. Carr and Xavier Bray, eds. *Velázquez*. Exh. cat. National Gallery. London, 2006.

Leah Kharibian. *Velázquez*. London, 2006.

Elena Ragusa and Miguel Angel Asturias. *Velázquez*. New York, 2006.

Francisco Pacheco and Antonio Palomino. *Lives of Velázquez*. London, 2007.

Javier Portús Pérez, ed. *Velázquez's Fables: Mythology and Sacred History in the Golden Age*. Exh. cat. Museo Nacional del Prado. Madrid, 2007.

Jonathan Brown. *Collecting Writings on Velázquez*. New Haven and London, 2008.

Fernando Checa Cremades. *Velázquez: The Complete Paintings*. Ludion and London, 2008.

Sarah Schroth and Ronni Baer, ed. *El Greco to Velázquez: Art during the Reign of Philip III*. Exh. cat. Museum of Fine Arts, Boston. London, 2008.

Picture Credits